Peekskill's
African American History

Peekskill's
African American History

A HUDSON VALLEY COMMUNITY'S UNTOLD STORY

John J. Curran

Assisted by Kathleen Moshier, James B. Taylor Jr.,
Allison Tapley Thompson and Offie C. Wortham, PhD

THE
History
PRESS

Published by The History Press
Charleston, SC 29403
www.historypress.net

Cover design by Marshall Hudson.

Cover image: Reverend Marshall of AME Zion Church led a solemn procession of two thousand people to the armory on Washington Street on April 7, 1968, in commemoration of recently assassinated Dr. Martin Luther King Jr. *Evening Star* photo.

Staff photographer Bill Johnson took some of the photographs reproduced in this publication from the former Peekskill *Evening Star*. Photographs of archives and artifacts at the Peekskill Museum are by the author.

First published 2008

Manufactured in the United Kingdom

ISBN 978.1.59629.484.4

Library of Congress Cataloging-in-Publication Data

Curran, John J.
Peekskill's African American history : a Hudson Valley community's untold story / John J. Curran ; assisted by Kathleen Moshier ... [et al.].
p. cm.
ISBN 978-1-59629-484-4
1. African Americans--New York (State)--Peekskill--History. 2. Peekskill (N.Y.)--History. 3. Peekskill (N.Y.)--Race relations. 4. Peekskill (N.Y.)--Social conditions. I. Moshier, Kathleen. II. Title.
F129.P37C88 2008
974.7'277--dc22
2008009387

Notice: The information in this book is true and complete to the best of our knowledge. It is offered without guarantee on the part of the author or The History Press. The author and The History Press disclaim all liability in connection with the use of this book.

"I want the truth revealed."
—Kay Moshier, 1984

"The story is of struggle and prosperity,
of mothers and fathers in the 1900s
working tirelessly to see their children complete
the high school education they never had,
and those second generations giving rise
to offspring who've become our physicians,
teachers and business people.
I want the truth revealed.
I want to spark interest and start a movement."
—Quoted from an article by Kathy Daley in the *Star*, February 1984

Peekskill's principal historian of African American history has been Mrs. Kathleen Amory Moshier, PHS Class 1937. She has been active with NAACP, National Conference of Christians and Jews, Peekskill Museum, and founder of Westchester African American History Study Group that published a quarterly newsletter in the 1980s.

Contents

CONTENTS

Preface

Peekskill's current estimated African American population is listed at 25 percent, or about fifty-five hundred people, of the total community population of twenty-two thousand residents. Most people work behind the scenes, quietly doing their jobs, taking care of their families and helping out when they can. This book is mostly about general trends, showing how those of African descent contributed to the creation of the Peekskill community and American society.

With no good alternatives, those of African heritage who accepted this nation as their home have for the most part done well for themselves and their families within this quirky, contradictory, sometimes hostile and often confusing American experience. Viewed together, the struggles, setbacks and accomplishments for those who can, in some way, trace their roots to Africa are an American success story.

I hope this publication provides a better overall understanding and appreciation of Peekskill's history. Knowing and valuing this history can provide a solid foundation for continuing our lives as individuals and organizations within this one community and the larger society.

This book grew from the interest of Waymond Brothers and La Fern Joseph in local underground railroad activities. When they contacted this local historian several years ago, I knew next to nothing about these topics.

By paying more attention and looking more carefully at the available evidence over several years, most of the material offered here was assembled. This publication is dedicated to Waymond and La Fern for their interest and encouragement. I thank them for stimulating me to research this intriguing American story.

Hudson Valley Slavery and Fighting for Independence

Human Slavery in New York State, Westchester, Cortlandt and Peekskill

This is a painful, difficult and troublesome part of the story. The realities of human slavery were unkind, perverse, inhumane and disconnected with fine-sounding words and appealing notions about "freedom, independence and democracy." This mixed message between idealism and brutality is the river uniting all the streams, heights and valleys experienced by African Americans in this land from the moment of their arrival to the present time.

Personal identities, family legacies and community associations that had been formed in Africa for centuries were violently disrupted when foreign invaders, driven by heartless economic greed, encouraged acts of piracy and kidnapping on a massive scale. Hundreds, thousands and millions of unassuming people were captured from their homes, rounded up and sold like cattle and then cruelly cast into new, unfamiliar roles as unwilling workers who received no just payment for their labors.

Kept as strangers in strange lands and constantly restricted day after day, people who had no visible hope on this planet turned to the invisible help and guidance of spirit and religion. The long, slow, painful progress from despair to personal success and common achievement is the inspiring story of former Africans and their descendants in the United States of America.

The reality that Europeans, Americans and some Africans conspired to take people from the African continent by force and then treated them as pieces of property for so long is a staggering concept to our modern imagination. This historical commerce, with human beings as the main commodity, went on for about two hundred years in New York as both a colony and a state, from about 1620 to 1825. At one point, New York was the state with the second highest number of enslaved Africans.

Such activities were common in the Hudson Valley, yet only fragments from those years remain for examination. Some antique paper documents exist relating to Peekskill

This legal contract details that a Peekskill resident purchased a "certain Negro boy named Harry" in 1812.

and Cortlandt, but what can these documents tell us? A yellowish, handwritten, single sheet of paper dated 1812 reads:

> I Margaretta Bradish of the City of New York, widow, for the consideration of one hundred dollars…bargain and sell to Isaac Vermilia of Peekskill, State of New York, a certain Negro boy named Harry.

By this legal contract, Harry "the Negro boy" is transferred from a widow in New York City to the Peekskill resident Isaac Vermilia for payment of $100. Most curious is that this sale was done "freely, quietly, peaceably and entirely without contradiction or hindrance from any person whatsoever."

How did this New York City woman and this Peekskill man know each other in 1812? Who was Isaac Vermilia, and why did he want to own a young black boy? Were Isaac Vermilia's motives commercial, benevolent or otherwise?

When one person can sell another like a piece of furniture, a used car or a horse, many questions arise and go unanswered. What became of young Harry? Are his descendants still living among us? The truth of human slavery was that each person experienced it in his or her own way.

Another Document Confirms Slavery

"Bargained and sold," reads a locally held document dated 1803:

> *Joseph Lyon of the County of Westchester…in consideration of the sum of $175… have bargained and sold…to Giles Newton…a certain Black Woman named Margaret, but commonly called Peg.*

It is clear from such papers that buying and selling "Black" humans in the United States, including New York, Westchester and Peekskill/Cortlandt, was legal, protected by contracts that held up in courts and enforced by its agents. It may seem somewhat less callous that the new owner, Giles Newton, was allowed to own "Peg" for only eight years, "at which time the said Peg shall be free." This captive would be set free in the year 1811.

As New York State governor, John Jay of Katonah pushed for laws that resulted in the gradual end of this morally corrupt activity. He signed an "Act for the Gradual Abolition of Slavery" in 1799 that phased out existing legal slavery in New York State. The plan was that slavery, officially and in practice, would be declared finished on July 4, 1827. We therefore see slave contracts that include wording about how long a certain slave could be owned before he was to be set free because owners and traders knew such an event was coming. A person's remaining "slave time" was negotiable and she was sold with her specific conditions written into the contract of sale.

Slave owner Joseph Lyon declared, "I promise to give up all rights and title to the child of the said Black Woman, now about three years old, named Dinah" after eight more years. Note the words "rights and title," as if he were talking about a piece of land.

The importation of human beings into New York for the purpose of slavery was outlawed in 1788, and antislavery movements in New York State were underway by 1803.

Numbers and Scope of Race Slavery

The numbers are clear when it comes to which people were being treated as slaves and which people were not. It was a matter of skin color and origin. In its New York colony in the year 1771, the racially sensitive English government counted, in Westchester County alone, 18,315 "Whites" and 3,430 "Blacks." Just about 12 percent of all the people residing in New York State in 1771 were blacks held in slavery. Yet not all blacks were subject to slavery. Though 80 percent were enslaved, about 20 percent were free around the country at that time.

The total population of people held as human property in Westchester County dropped by half between the years 1771 and 1790. The total percentages also dropped from 12 percent to about 6 percent. The 1790 census counted 1,419 people held as slaves in Westchester County. Cortlandt and Peekskill counted 66 people (or 3.5

percent of their total population) as bound in legal, race-based slavery in 1790. It seems amazing that seven years after the American Revolution (1776–1783), which proclaimed "independence and freedom" in the land, New York State was still counting slaves among its residents.

But numbers alone don't tell the whole story. The use of labor without pay, forced work by intimidation and the buying and selling of human beings have unfortunately been frequent activities practiced in many cultures for many thousands of years. Europeans saw America as a land with tremendous potential for wealth of all kinds. But where were the workers needed to cut forests, dig ditches, load and unload cargoes, haul products, grow food and cash crops and operate primitive factories?

The Native American tribes defended their lifestyles and land as best they could in life-and-death battles with the invading Europeans. But this conflict was mostly a case of Stone Age people fighting a machine age foreign force, and each side was unforgiving in its victories. The natives could more easily escape into the woods or natural landscape, and this one advantage provided protection that many escaped Africans survived by being accepted into Native American camps.

One could make a great deal of money in the transatlantic human trade from Africa to America. Dark-skinned Africans were, by sight, different from white-skinned Europeans and were therefore easier to catch if they escaped in America. This race or skin color difference has been part of the American story ever since.

For about three hundred years, Spanish, English, Dutch and other ships made a profitable business crossing the Atlantic Ocean with captured Africans as useful cargo for sale to willing buyers in the Americas. This corrupt trade started soon after the Columbus expeditions arrived from Spain, lasting from the early 1500s through the 1700s and into the 1800s.

That racially based American slavery lasted as long as it did—protected by law and custom and requiring a tremendous internal civil war resulting in more than a half million deaths to finally abolish it—is a peculiar, tragic reality that Americans in general do not entirely appreciate.

Peekskill and Cortlandt Slave Owners

It is a comforting delusion and error to suppose that Peekskill and Cortlandt, settlements that grew side by side and were very much intertwined, did not experience human slavery. Peekskill and Cortlandt slaves worked as personal servants or field hands. They worked at the nearby docks or mills, hauling lumber, boxes or barrels of ship cargo. They worked in the tanning yards, slaughterhouses and mines.

The U.S. census lists "66 slaves," who were certainly African, in Peekskill and Cortlandt in 1790. Who were these enslaved people and who were the slave owners? Most people who suffered and endured enslavement in this region were not personally identified. However, the local slave owners were named and identified.

Pierre Van Cortlandt, a primary rebel against British rule and the first lieutenant governor of the New York State he helped to create, personally owned eight people as slaves in 1790, and nine such persons in 1800. His son and Revolutionary War hero Colonel Philip Van Cortlandt owned seven people as slaves in 1800.

A large percentage of the communities' original founders were slave owners after the War for Independence. Among these men was Daniel Birdsall, who hosted General Washington at his home on Main Street. Pelatiah Hawes is named on many early deeds as a substantial landowner in Peekskill and Cortlandt. He owned four people as slaves in 1790. William and Sampson Dyckman, Richard Curry and Joseph Drake each owned two people, and we have already seen the slave contract evidence about Isaac Vermilia of Peekskill.

Resident John Leslie, whose ancestors reach back to the Revolutionary War, explained that one of his distant ancestors, Dr. Nathaniel Drake, owned one person as a slave in Peekskill while living on Spring Street. This enslaved person was set free in the late 1700s and became a servant coach driver or "private chauffeur" for the doctor in making house calls.

An outstanding exception to these slave owners was the local Brown family who were Quakers, or Society of Friends members. Nathaniel Brown was a successful Peekskill businessman, a dock, mill and property owner who worked against the practice of human slavery in the 1700s. Nathaniel's son James Brown refused to handle or consume products produced by slave labor. This was his personal boycott against the economic system that produced such items. As we will see, this James Brown also gave local underground railroad activist Hawley Green his start in the real estate business. "James Street" and "Brown Street" are named for this exceptional Peekskill antislavery Quaker family.

It is also quite interesting that Frank Moshier is clearly indicated as a "colored tutor" or teacher living on his own property at the river end of Main Street before 1800. A map of that date shows the house and the descriptive caption.

"Old Slave House on Main Street"

A slave house on Main Street? A photograph in the former *Evening Star* newspaper on August 16, 1947, shows such a ramshackle dwelling, with the headline: "Old Slave House on Main Street Gradually Collapsing."

When slavery was officially and practically ended in New York State after July 4, 1827, where do we suppose those people who had once been enslaved went? What did they do? It seems that each person dealt with the new situation as best she could in her individual way.

We have a documented example of Pelatiah Hawes's son, Solomon Hawes, as he let his enslaved people go free in the early 1800s. This event is recorded in the section "Freeing Slaves Here" by former Peekskill historian Carlton Scofield in his 1969 book, *Old Village by the River*. Scofield writes: "Mr. Haws placed a five dollar bill in the hand of each slave, or told them to return to the house until they found employment."

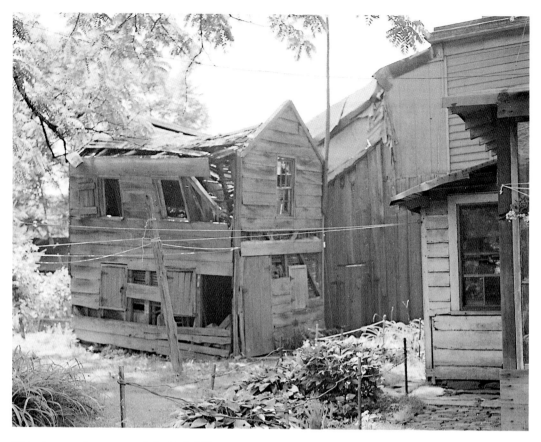

This photograph accompanied a Peekskill newspaper article on August 16, 1947, with the headline: "Old Slave House Gradually Collapsing."

The four freed black workers were offered a choice by their former white master of going out into the world with their five dollars, or not taking the money and returning to his house. Scofield continues:

> On coming to the last slave, an aging woman who had been given to him on his marriage day (apparently as a present) reproached him for turning her out of his house… Whereupon Mr. Hawes declared that it was her home if she wished as long as she lived. She did indeed stay, and lived to be over a hundred.

Many people once held as slaves were no longer young or healthy, and they simply had nowhere to go. It wasn't possible in some cases to simply take some money and go off on their own. It is possible that after being set free they didn't have the desire, or the opportunity, to go somewhere else. They simply stayed in the same buildings or places where they already lived.

The old slave house on Main Street was probably home to generations of people who once had been required to work for nothing. With births and deaths and everything else in between, descendants of former slaves likely occupied this humble house for several decades afterwards.

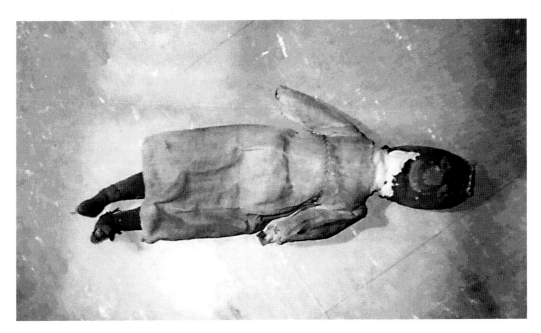

This well-fashioned doll at the Peekskill Museum was likely used during slavery days. The hands, feet and head are certainly "colored," as they are made of red cloth.

There are few remaining objects from this area's slavery days. An antique homemade "slave doll" at the Peekskill Museum could well have been a plaything for a girl who grew up in this Main Street house. Who were those residents? What were their names? What became of their families? The unclear fogs of the past can often be cleared with warmth and sunlight.

An African American Revolutionary War Veteran

Why would black Americans held captive as slave property fight on the side of American rebels against English colonial control? Most did not have a choice about joining the war, as their owners sent them into military service as their servants. But a servant and a soldier with a weapon are two very different roles.

In desperation for manpower, the American Congress in 1778 started a policy that allowed those held as slaves who served for three years in the Continental Army of the United States to become free people. They would become veterans entitled to the same pensions and land grants that other veterans received.

It was risky and dangerous for Americans of any color to serve as soldiers during the Revolution. They endured severe ordeals of military camp life and combat during long, weary years. There was barely enough food or clothing and the soldier's lifestyle offered little comfort to those daring individuals.

Self-interest is usually a strong driving force in any human activity. The chance to be at least on an equal level, to maybe share in the opportunities and wealth

this new nation offered, may have seemed an attractive opportunity to black soldiers of the Revolution. But these benefits could be reaped only if Americans won their war.

The Continental Army was this country's first racially integrated fighting force. White and black soldiers served side by side in various regiments. A person's skin color and social background were less important than the need for soldiers taking on the world's most powerful military forces, which at that time came from England.

The price of failure would have been severe. An army private, Joseph Plumb Martin, who was in Peekskill several times during that war, wrote the most detailed and complete memoir of a Revolutionary soldier. His book is titled, *A Narrative of Some of the Adventures, Dangers and Sufferings of a Revolutionary Solider.*

Those foot soldiers endured dangerous situations while receiving little food and clothing, and often no payment. Martin wrote:

> *Almost everyone has heard of the soldiers of the Revolution being tracked by the blood of their feet on the frozen ground. This is literally true, and the one thousandth part of their sufferings has not, nor ever will be told.*

It is most interesting to consider the wartime experiences of the black soldier John Jacob Peterson. Peekskill is fortunate that historian Mrs. Kathleen Amory Moshier offered considerable research time and skill in detailing the military experiences of her ancestor through marriage, John Jacob "Rifle Jack" Peterson.

Rifle Jack Peterson owned a rifle for military purposes when most infantry weapons in use at that time were muskets. This indicates that he was a marksman or sharpshooter. Living on the Van Cortlandt Manor lands, Peterson was a mature thirty years of age when the Declaration of Independence was announced in 1776. He became a soldier with Colonel Philip Van Cortlandt's 2nd New York Line Regiment of the Continental Army.

Private Peterson was a member of the 2nd Regiment stationed in the Fort Hill area in March 1777, when British soldiers arrived by water and attacked on land. American military forces at the Peekskill headquarters were at their lowest point during that early spring. This weakened situation explains why the British directly targeted Peekskill on March 24 and 25, 1777. Also present on the hilltop was John Mosher, attached to the Continental Army's 4th New York Regiment.

Peekskill was then the Hudson Valley's Continental Army headquarters. It functioned as a troop camp and supply area for the several river fortifications at Fort Independence, Fort Constitution, Fort Montgomery and Fort Clinton. Peekskill's several small mills, docks, slaughterhouses and tanneries supplied food, ammunition, cut lumber and clothing to the desperate American army.

The entire British operation involving soldiers and sailors took one week from start to finish. They arrived with a warship and several support vessels to land five hundred infantrymen as an aggressive invading force. Sailors hauled three cannons to Drum Hill overlooking the small valley below. They then opened fire at Americans stationed on

Fort Hill, just across the way above Oakside School. Rifle Jack was present on the scene for these dramatic events.

Outnumbered and outgunned, General MacDougall's forces at Peekskill retreated to their backup camp at Continental Village. The next day American reinforcements encountered a British advance party in a fierce counterattack that pushed British troops back onto their ships, and they left for New York City that night. Lieutenant William Mosher was an officer with the 1st Westchester County Militia led by Colonel Joseph Drake.

Soldier Peterson was also present at the crucial battle at Saratoga, New York, in October 1777. American riflemen were accurate and deadly in firing upon the advancing British army. It was a humiliating and important defeat when General Burgoyne surrendered his entire army, stopped in its movement from Canada by Rifle Jack Peterson and others like him.

John Jacob Peterson Became a Hero

Rifle Jack Peterson and Moses Sherwood were American soldiers stationed as lookouts at the tip of Croton Point that fall day of September 21, 1780. Peterson was now a thirty-five-year-old black man and Sherwood a nineteen-year-old white man connected to the Continental Army's 2nd Regiment of New York. They were most likely part of a "light infantry" unit that was allowed independent action upon the enemy and whose men were good shots and could travel quickly.

While posted near an orchard at the very northern tip of Croton Point (then known as Teller's Point), they clearly noticed the tall-masted British warship *Vulture* anchored in the Hudson River off Haverstraw. On the morning of the twenty-first, the *Vulture* sent a British landing party of twenty-four soldiers in a gunboat powered by oars and a small sail headed straight for Croton Point.

The two American soldiers saw the boat approach their location. Before the enemy reached shore, Peterson and Sherwood, positioned behind a large rock, directed musket and rifle fire at the landing party, killing two men, according to one account. Faced with the unexpected surprise fire in their direction from an unknown number of defenders, the two dozen British soldiers quickly withdrew back to the *Vulture*. The warship then opened its side cannons upon Croton Point.

Privates Peterson and Sherwood, in their actions as foot soldiers, set in motion a sequence of events that many historians credit with saving the entire American military effort in the Hudson Valley during the Revolutionary War.

Consider the situation: Peterson and Sherwood were in danger from more than twenty advancing British soldiers. The two Americans repelled this enemy landing force. The warship then fired cannons at them. What they did next changed the course of history. They decided to take on the warship.

Resolute, defiant and canny, they correctly figured that if cannon fire were reaching them from the *Vulture*, they could return such blasts toward the British ship anchored off Haverstraw.

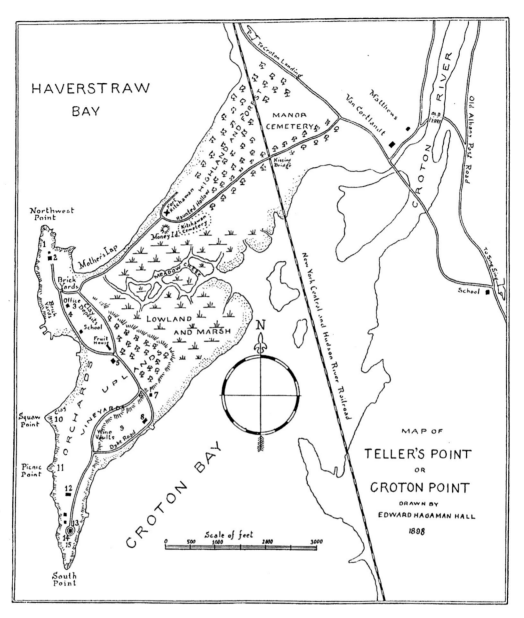

This graphic shows in detail that American Privates Peterson and Sherwood were positioned at the northern tip of Croton Point when they first observed the *Vulture* and repelled its landing party. The cannon battery was set up the next day at the point's very southern tip.

Privates Peterson and Sherwood rode on horseback to their nearest American command post at Fort Lafayette located at Verplanck's Point. They gave firsthand accounts of their recent contact with the *Vulture* to the commanding officer.

The sound of booming cannon and puffs of smoke had already been noticed at Fort Lafayette. Upon hearing the report from his two soldiers that the British warship

was within artillery range, Colonel Livingston ordered to Teller's Point two cannons and a howitzer with an artillery squad. The two cannons were likely four-pounders, as the four-pound cannonballs were easier to transport and could reach farther across the river. One report mentions a six-pounder. The howitzer had more of a vertical trajectory that could be used against a possible landing force.

At 5:30 a.m. the next morning, the Americans began a steady, two-hour cannonade toward the *Vulture*. The ship was hit six times by shells, causing some rigging and wood damage. The British captain was slightly injured. The American ammunition stockpile was hit and exploded.

At risk for more serious damage, the *Vulture* decided to depart from its anchorage, and it was slowly rowed by sailors downriver and out of range. When the *Vulture* was forced to withdraw from its fixed location in Haverstraw Bay, it left behind onshore an extremely important person involved in a secret conspiracy. That officer was John Andre, a British major and adjutant to Sir Henry Clinton, the British commander.

Andre was deeply involved in a secret nighttime meeting with General Benedict Arnold, the commander of all military forces in the Hudson Valley. They were negotiating the transfer of Arnold's important military information, and his loyalty, for an amount of money. General Arnold personally gave maps of American fort positions and troop strength at West Point to the British officer. This was clear treason against the American cause.

The two officers talked and bargained all night. What they did not expect were the actions of the two soldiers John Peterson and Moses Sherwood that early morning. When the *Vulture* moved to get away from American cannon fire, Major Andre remained alone and stranded onshore within enemy territory.

The conspiracy quickly unraveled. Wearing civilian clothes, Andre was captured at Tarrytown. Within two weeks he was tried and hanged as a spy at Tappan, New York. Traitorous Benedict Arnold escaped onboard the *Vulture*.

Mrs. Moshier, as a Peekskill Museum trustee and secretary, was responsible for restoring, mounting and dedicating the Revolutionary War's "America's Most Famous Cannon" on the front lawn at the Union Avenue museum. Her son, David Moshier, a successful painting contractor, was part of these events.

The Peekskill Museum four-pounder cannon is physical evidence of those dramatic events of September 1780, a visible artifact that recalls the actions of the two patriots responsible for frustrating an important conspiracy. The museum artillery weapon may indeed be one of the very same cannons that fired upon the *Vulture* in 1780.

The mounted and dedicated cannon was recovered from the remains of the American-held Fort Lafayette. It was donated to the Peekskill Museum by a member of the notable Bleakley family, whose home was located where Fort Lafayette once stood. The authentic Revolutionary War artillery weapon was made in Connecticut in 1766. A historic memorial plaque also located at Croton Point recognizes the patriotic contributions of soldiers John Jacob Peterson and Moses Sherwood.

For his successful service throughout the war, veteran Peterson received a pension payment from Congress equal to "others of the white race," and land ownership

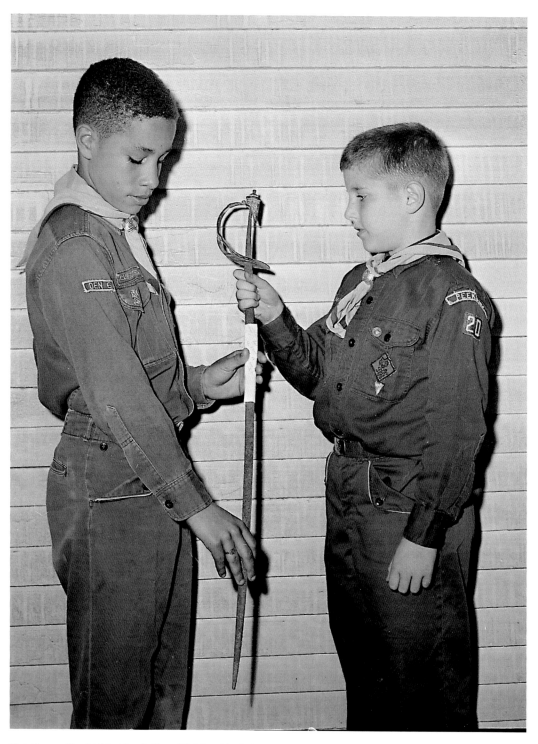

Cub Scouts David Moshier (left) and Richard Babchak examined a Civil War sword at Peekskill Museum in 1965.

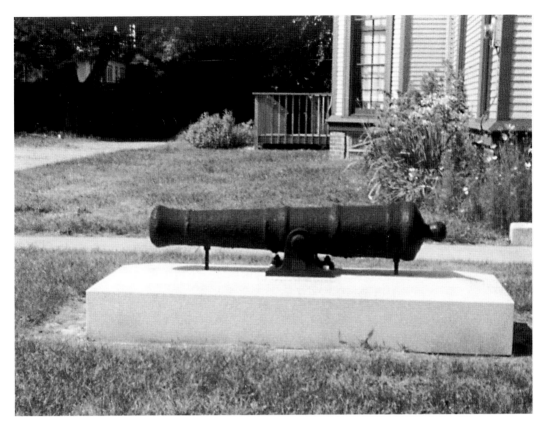

This historic cannon mounted in front of Peekskill Museum was connected to the 1780 Arnold-Andre conspiracy and the bold actions taken by Privates John Jacob Peterson and Moses Sherwood.

on Van Cortlandt Manor. He and his wife raised six children. His daughter Harriet Peterson married Harrison Moshier. These two families thus were connected more than two hundred years ago. Revolutionary War veteran John Jacob Peterson is buried at Bethel Cemetery in Croton. Moses Sherwood lies in Sparta Cemetery in Ossining.

The First Integrated Army

It is estimated that five thousand Americans of African heritage served as soldiers in the Continental Army of the United States. The names of other local African American patriots who aided in securing American independence are unclear, as no recorded or written distinctions were routinely made between white and black soldiers in the various lists during that war.

French officers fortunately made personal observations after 1780. When the French army arrived in America in 1781, their officers were surprised by the numbers of black soldiers they saw serving alongside white soldiers in American units. One French officer commented on the American military that he saw in Westchester on July 5, 1781:

I am full of admiration for the American troops. It is unbelievable that troops composed of men of all ages, even children of 15, of blacks and whites, without money, poorly fed should walk so well and stand the enemy's fire with such firmness.

The 1ˢᵗ Rhode Island Regiment of Continentals was mostly composed of black soldiers. This unit suffered a surprise attack by the British at Pines Bridge, New York, in 1781. Allison Albee tells their dramatic and devastating exploits at Yorktown in a recently republished book, *The Nasty Affair at Pines Bridge.* The Yorktown Historical Society reprinted the book in 2005.

This Rhode Island regiment later participated in the Grand Review of French and American armies at Verplanck's Point in 1782 at the end of the war. A French officer wrote:

Three-quarters of the Rhode Island regiment consists of Negroes, and that regiment is the most neatly dressed, the best under arms and the most precise in its maneuvers.

Inside the Hudson Valley Headquarters

The Birdsall home, once located on Main Street, was used as Revolutionary headquarters for General Washington when he stayed over at Peekskill. There, he slept, dined and consulted with his officers. In Joseph M. Fox's book, *The Story of Early Peekskill*, the following interesting statement is made:

An old colored woman, who in her younger days was a servant in the Birdsall household and claimed to have waited on Washington and Lafayette, died in 1844.

That a colored woman was a servant to the Birdsall family is confirmed by evidence that Daniel Birdsall once owned a black person as a slave. She was likely a house servant and probably stayed on after abolition in 1827.

The house was a modest, yet important building. It was convenient on Main Street for the Continental Army based here and because the Birdsall family took the American side during the war.

Fox also wrote:

Tradition has it that for many years after the Revolutionary War, the furniture in the rooms occupied by Washington and Lafayette, as well as the old clock in the hall, remained in the same relative position as during the war.

The important Hudson Valley regional command was personally given to General Benedict Arnold by his commander in chief inside this Peekskill headquarters on August 3, 1780. We can only wonder if the unnamed colored woman working inside that house at that time observed this momentous event.

"True to the Patriotic Instincts": 1812

Can patriotic instincts be inherited? It seems amazing that the son of Revolutionary War patriot John Jacob Peterson also became a military hero in the next major war with England, known as the War of 1812. Jacob Peterson grew up on Cortlandt Manor. Upon his demise in 1831, Peekskill's *Highland Democrat* newspaper printed a six-inch obituary stating: "The only surviving son of John Peterson, whose services in our revolutionary struggle were of marked importance."

Rifle Jack's son Jacob was described as "true to the patriotic instincts of the age." He served with several of his brothers in the Second War of Independence against England. The War of 1812 turned out to be three years of warfare.

This was largely a naval conflict, with about two thousand African American veterans composing as much as 20 percent of some ship crews. The main issue between the United States and England was the capture of American sailors for service on English ships. Much of the fighting during the war years 1812–15 was on lakes, rivers and the Atlantic Ocean.

Jacob Peterson at that time specialized in naval issues. "He [Jacob] familiarized himself with the river and coast navigation." His life story then took a dramatic turn. As an American sailor,

> *Jacob Peterson was made a prisoner and impressed into the British service, torn in a moment from his country, kindred and friends he was forced to serve under a flag he hated.*

Jacob became an example of England's aggressive "impressment" of American sailors to serve on their ships.

Jacob was "carried into far-off climes" aboard British ships. The obituary is not clear what these "far-off climes" were, but they were likely areas of the Caribbean and South America. There he stayed "for long weary years and did not return to his own free home until many years afterwards." Jacob Peterson's descendants continue to live in Peekskill and Cortlandt.

Escaping Slavery and the War for Its End

Posted: "Ten Dollars Reward…Ran Away"

It is a mistake to assume that slavery in Peekskill/Cortlandt was any less harsh, strict and organized than anywhere else in this country. Many human beings held as legal property tried to physically escape. In running away, they usually broke a law or two, including "theft," as amazing as this may seem. An owner could therefore post an advertisement in a public newspaper offering a cash reward for whoever should find and return his lawful human property.

This is the case with Peekskill's very first newspaper. Published and printed by Robert Crumbie on the north side of Main Street in 1811, just a few lots east of the present city hall building, the *Westchester Gazette and Peekskill Advertiser* newspaper of January 15, 1811, carried an announcement for a runaway slave: "Ten Dollars Reward." (This money would amount to a few hundred dollars in year 2007.) "Ran Away from the Subscriber." (A regular newspaper reader and subscriber was the slave owner.) Next came a very detailed and curious description of the fugitive:

> *A negro man slave about 21 years old…He had on a new dark brown cloth round about, or a sailor's jacket and trousers, a red and white marseils* [quilted stripes] *waistcoat, a new pair of course shoes, a new muslin shirt, a white muslin cravat and a half worn hat…He is about five feet eight or nine inches high, well made active and is named "York," but sometimes calls himself John Cook or James Cook.*

If a bounty hunter or slave catcher should be so interested in this assignment:

> *Whoever will take up the* [search and capture] *and deliver him either to the subscriber* [first name missing] *Thompson Esq.* [lawyer] *at Sing Sing* [Ossining] *shall* [be paid the reward], *Haverstraw, Rockland County. Walter Smith.*

This advertisement for an escaped "Negro man slave" was printed in the January 15, 1811 edition of the *Westchester Gazette and Peekskill Advertiser* when its office was on Main Street.

This "negro man slave" was no ragged runaway, but clearly valuable property. He is described wearing a sailor's uniform, new shoes, a fancy vest and neck garment of those times, a hat and a new dark brown cloth, probably used as a cloak in the winter weather.

This printed reward notice offers us many intriguing pieces of information. We learn that about two hundred years ago, Peekskill's first newspaper reached to Ossining and into Rockland County, as the paper's slave-owning "subscriber" lived in Haverstraw, Rockland County, on the Hudson River's west shore. Why, then, is this reward announcement posted in a Peekskill paper on the river's east side?

It seems likely that the described fugitive crossed over the river in his escape from west to east. How did he do this? There were no bridges in those days. Only a few ferries went back and forth. Steamboats didn't appear until Robert Fulton's *Clermont* traveled from New York City to Albany in 1807. There were as yet no railroads, underground or otherwise.

The personal names are another revealing detail. Although this twenty-one-year-old man was named "York," as slaves were given only one name as identification, he called himself "James Cook." English Captain James Cook was a famous explorer of that era, well known around the world for his discoveries and adventures in the late 1700s. Captain Cook sailed to the Pacific Ocean and the Hawaiian Islands, where he died. Was this runaway man at the prime of his life an adventurer at heart, skilled at sailing and navigation?

The sailor jacket and pants descriptions are revealing clues. Was runaway "York" or "James Cook" in fact a skilled sailor who earned money on the river for his Haverstraw owner? Was self-named James Cook his own pilot in crossing the river? Did this "well made active" runaway slave figure out that he could make more money on his own, perhaps in Canada?

Almost everything traveled by water before railroads, automobiles, airplanes or even good roads. The Hudson River was quite busy with water traffic in 1811. Hundreds of cargo and passenger sloops and other vessels were locally built and employed. Yonkers, Nyack, Haverstraw, Peekskill and Newburgh had extensive docks and piers for riverside commerce between New York City and Albany. Peekskill Bay benefited from three extended docks and several piers with constant import and export for its industrial mills.

We may assume that many who traced their roots to Africa did much of the hard labor at wharves, docks and warehouses. This was the whole point of slavery, to make money by having someone work for you at no pay.

The "Ten Dollars Reward" newspaper announcement in year 1811 hints at other events taking place at that time. A full-scale war with England was coming the following year in 1812. Much of that conflict had to do with control of naval traffic. Mr. James Cook of Haverstraw saw a good opportunity to get away, and he took it. We hope he made it and did well with his life.

Escape on the Underground Railroad

Enslaving people of African ancestry was an active systematic practice in the Hudson Valley after the first and second American wars with England. The loudly announced American "revolution" in human values clearly did not apply to everyone. Before New York Governor John Jay signed a law leading to the end of slavery in this state, escaping from its confinement was limited, risky and usually done alone.

A newspaper business advertisement in the January 4, 1800 edition of the *Ulster County Gazette* of Kingston stated: "FOR SALE. One half of a saw mill…and an inexhaustible supply of Pinewood. And also a stout, healthy, active Negro Wench." Buy some lumber, buy a person. The buying and selling of people as property was a routine transaction along the Hudson River in the early 1800s.

American iron locomotives powered by steam and rolling on iron rails became increasingly available in the 1830s, '40s and '50s, and thus were called railroads. The first such rail roadway reached Peekskill in 1849 from New York City.

The famed underground railroad was not really a rail system, nor was it under the ground. It was an organized national network of like-minded individuals with strong personalities living in cities, small towns and farms. These people not only thought that owning human beings as property was a morally corrupt and inhumane practice, but they also did something about it. They went looking for "passengers to take on a train ride to freedom."

Harriet Tubman broke free of her enslavement in the South in 1849. She stated, "I crossed the line of which I was for so long dreaming. I was free, but there was no one to welcome me." One might escape, but then what? There was no welcome and no help. Only fear, poverty, loneliness and danger offered themselves as companions.

Ms. Tubman personally experienced such agonizing freedom. A woman of strong character and organizing abilities, she immediately became an active creator and leader in the secret network that helped many black Americans escape slavery's confinement, physical misery and personal outrage.

People with black, brown and white skin tones, mostly people with religious faith, were able to link together, communicate and physically time arrivals, departures and layovers through several states and into Canada with amazing efficiency.

The underground railroad was a humane transportation conspiracy. This support system was known as a "Freedom Line," "Emancipation Car," "Gospel Train" and by other names. The secret train to freedom was invisible, magical and effective. It offered escape and a better life. Only those who were its passengers and conductors saw this train. It was not supposed to be seen by anyone who was not part of its activities. This train operated out of sight, or "underground."

By breaking laws in several states, especially the harsh national Fugitive Slave Law of 1850 that required people to return slave property to their owners with penalties for those who interfered, those people who helped refugees from slavery risked legal and physical dangers.

Ohio was the most active state, with underground railroad trails and active participants. The Oberlin-Wellington Rescue was a team of forty black and white men who were jailed for forcefully tracking down slave catchers. The voluntary guides, conductors, operators of safe houses and many others whose names will never be known decided to take extra steps to travel uncertain and unseen roads because they felt and realized this was the right thing to do.

Secret design symbols sewn onto quilts were hung outdoors to give travelers who could not read the necessary directions, signals and messages. Code words and phrases such as "conductor" and "safe house" were part of the secret language. A "brakeman" would make contacts for refugees along their way. "Agents" and "pilots" gave instructions to their "passengers" to "follow the drinking gourd" in the northern sky. The Big Dipper (drinking gourd) arrangement of stars was a kind of compass to the North Star that allowed those moving at night to keep a course northward.

Similar to escapes during World War II in European countries under Nazi occupation, the American secret "underground" rescue system was historically equivalent to those brave individuals who assisted Jews in hiding and running away to avoid death camps.

Revolutionary War leaders wrote of "self-evident" truths: "That all men are created equal, that they are endowed by their Creator with certain unalienable rights." If all Americans are indeed entitled to "Life, Liberty and the pursuit of Happiness" as stated in our Declaration of Independence, then these secret railway volunteers were patriots in the best meaning of the word.

Hawley and Harriet Green's 1112 Main Street Safe House

The underground railroad was a system of human alliances, of spoken and unspoken understandings. It was mostly about people taking risks to help other people, intentionally breaking laws in the service of Americans being denied their rights and freedoms. It was composed of daily acts of bravery in a humanitarian cause.

The remaining evidence of underground railroad activities in Peekskill suggests that its overall involvement was active on an undetermined scale in terms of the numbers of people involved. Yet, any community that was part of such humane activities should be proud of its participation.

A "station master" was in charge of a "safe house" or "station," where shelter and food would be offered to the runaways. One such safe house has been identified at 1112 Main Street in downtown Peekskill, a property once owned by free African Americans Hawley Green and his wife Harriet in the 1830s. It is also recorded that Mr. Green had "strict religious beliefs." He risked his own safety and income to help others who were less fortunate. He did these things while "he had his own troubles."

Hawley Green, born in 1810, was a well-known and well-liked businessman who ran a successful downtown barbershop on North Division Street. There is no evidence or mention of his having experienced slavery. Three separate written local sources indicate that Hawley Green "helped many a poor slave brother on his way to Canada." These sources are former local historian and author Colin Naylor's book *Civil War Days in a Country Village*, author Stephen Horton's *Personal Recollections of Peekskill in My Boyhood Days* and an antique Peekskill newspaper account. Green was clearly an active Peekskill participant in underground railroad activities during the 1840s, '50s and '60s.

Hawley Green was a real estate dealer in the 1830s. How was a twenty-seven-year-old Peekskill man of African descent able to own a house and property on Main Street near James Street in the 1830s? He bought it.

Mr. Green paid for the land and its building with mortgage payments. The mortgage was given by the former property owner James Brown, an important member of Peekskill's primary antislavery Quaker family. Their signed deed agreement reads:

> *I have consented to release the premises above mentioned…so that Hawley Green, his heirs and assigns shall take and hold the same free and clear…having discharged the mortgage… Executed to me by the said Hawley Green and Harriet his wife.*

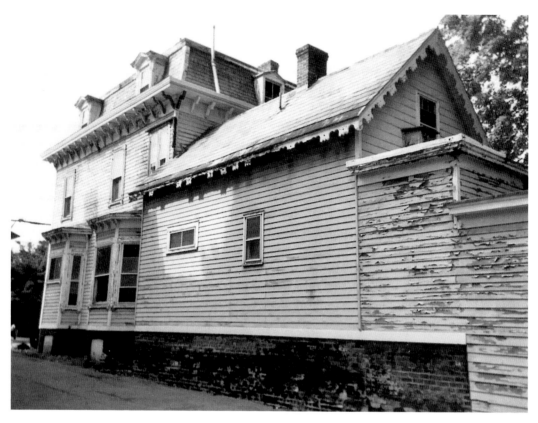

A property at 1112 Main Street was once owned, and later sold, by Hawley Green in 1839. The front house is post–Civil War, while an older and simpler structure is attached at the rear

The handwritten agreement of 1837 shows the clear bold signatures of "James Brown" and "Hawley Green," declaring Mr. Green to be the property owner. This transaction apparently started his property ownership. As landowner, this also qualified him to vote in village elections.

Hawley Green then sold the 1112 Main Street property to William Sands in 1839. Sands is not a common Peekskill name, but there are numerous Sands family names listed in the Quaker Cemetery at North Castle. As a member of influential Quaker society, William Sands was surely a friend and acquaintance of James Brown as a fellow Quaker.

The house at 1112 Main Street now appears as a large post–Civil War house with a mansard roof style fronting the street. Back in 1839, the house was a simpler affair. There is an older domestic structure attached to the back of the more recent Victorian-style mansion facing Main Street.

People tend to prefer conducting business dealings with those they know. It is clear that the Quaker members James Brown and William Sands knew each other, and they entrusted Hawley and Harriet Green during property negotiations.

More Land Dealing and Good Works

Hawley and Harriet Green are identified by name as owners of three Peekskill buildings in year 1837. They owned one property on Main Street, one on James Street and another on Howard Street, according to a detailed village map of that time.

There was also the matter of Gerrit Smith's generosity. Adding to the Green family's local real estate success, they also received a considerable land grant from this wealthy white antislavery advocate. Mr. Gerrit Smith was an extremist in his active opposition to slavery. He gave money to John Brown for his desperate suicidal raid at the Harper's Ferry military arsenal just before the Civil War.

Gerrit Smith gave land grants to nine Peekskill African American residents. Each was given 40 acres of upstate New York wilderness land in 1846 and 1847. Of these nine parcels, Hawley Green received an unusually large grant of 160 acres, identified as Lot No. 245 in Essex County.

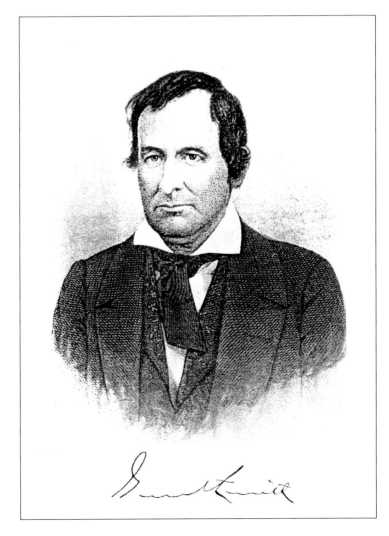

Gerrit Smith was a wealthy upstate New Yorker who donated land and money to African American citizens before the Civil War.

Why did this one Peekskill resident receive such a large section? We can only suspect that Hawley Green was also known to Smith for his antislavery work, and thus received four times the land areas given to others. All together, Smith donated 120,000 acres to three thousand free black New Yorkers between the ages twenty-one and sixty who did not drink and were of good personal character.

Other Peekskill African American residents who received such land grants were Abraham Ray, Riley Peterson, Horace Holden, George A. Ray, Henry Jackson, Moses Stedell, George Butler and Goodman Green. The land was unimproved acreage in upstate New York wilderness areas. Even so, having title to 40 or 160 acres, or even 1 acre, meant that one could sell this property for cash.

Owning land is usually connected with the word "real," as in real estate. Owning land was evidence of wealth, social standing and a qualification for voting in those days. Connections, wealth and social positions were not only what Hawley and Harriet Green were all about. They had good deeds in mind.

Hawley Green bought a land parcel on the north side of Main Street from Peekskill iron stove maker Reuben Finch in 1865. Green proposed to build a two-story house on this lot for a very specific purpose: "On the other end of the lot it is proposed to build a church for the African Female Missionary Society." This proposed "African Female Missionary Society" was to be located just about directly across from what is now the Museum for Contemporary Art building. There is, however, no further historic mention of this project.

The Green family burial plot at Hillside Cemetery is enduringly emotional in its attention to family unity. The burial head stones for Hawley (1810–1880) and Harriet (1816–1886) are inscribed on their fronts with birth and death dates. Rare inscriptions on the back of each standing stone indicate "Father" and "Mother."

Another gravesite is for their Civil War veteran son William Gipson Green. He was a "colored" corporal in a U.S. heavy artillery regiment. William Green was born in 1840 and died in 1900. An interesting little story about this man was written by Stephen Horton in his *Personal Recollections*.

> *With Hawley's son "Gip" I played my first and last game of cards for money in my life. So luck would have it, I was caught by Mrs. Strang, and she gave me such a talking to that I forever quit.*

Nearby is the burial site and headstone marker for their daughter. Eliza Green was born on April 25, 1838, was married to John Williams and passed away on March 19, 1876. An adjacent headstone reads: "Robert A. Green. Born July 3, 1857, Died March 26, 1896."

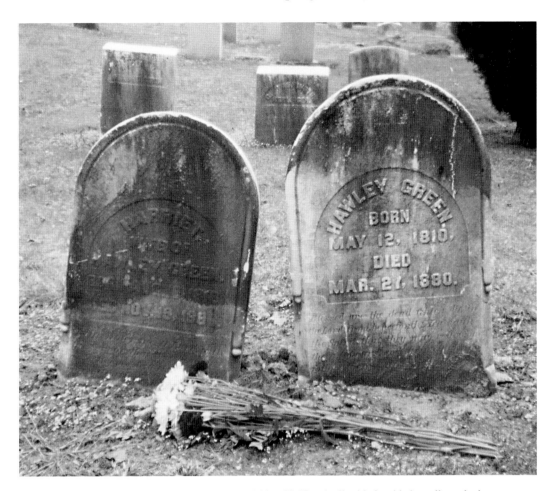

Underground railroad activist Hawley Green and his wife Harriet lie side by side in well-marked, front-and-back gravestone memorials at Hillside Cemetery in Van Cortlandtville.

AME Zion Church and Underground Railroad Activities

Peekskill's African Methodist Episcopal Zion Church members were certainly active in helping, guiding and supporting those escaping slavery before and during the Civil War. This country's first AME Zion Church was organized by former slave Richard Allen at Philadelphia in 1816. Distinctly African American, the church organization soon spread to several other states in its mission to assist those who endured, and those escaping from, slavery.

This local church organization at first held meetings in a building on the south side of Howard Street. Three Quaker sisters from the Brown family donated their land on Park Street for the AME Zion Church in 1852. Previous financial and property dealings between the Brown family of Quakers and the Green family of African Americans may explain something about the origins of this Peekskill church property.

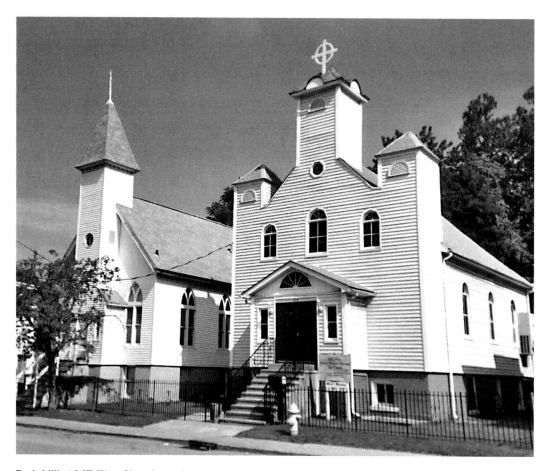

Peekskill's AME Zion Church was located on Park Street in 1852 and is now occupied by the Church of the Comforter (left). The AME Zion Church congregation has moved next door into the former St. Peter and Paul's church (right).

The Fugitive Slave Law of 1850 required that escaped slaves be returned to their owners. There were penalties for those who refused to cooperate in helping the slave catchers. There was a real danger that free blacks could also be captured and then sold into slavery. Many Northern states refused to abide by these laws and in turn passed personal liberty laws that would provide legal assistance to those challenged by this Fugitive Slave Law. One identifiable Peekskill location in the local underground railway system is its original African Methodist Episcopal Zion Church, also known as AME Zion Church, now relocated at 1220 Park Street.

A search for direct connections was undertaken by a recent Pace University Law School study, "Memorandum: Historic Preservation of Underground Railroad Sites in Peekskill, New York, January 6, 2000." The Pace University report discovered a secret panel leading to basement rooms that could have hidden escaped slaves.

This panel has not been altered or repaired, and was discovered when a cabinet was moved from in front of it. There is a space beneath the stairway leading towards the north

of the building, as well as extra space leading to the south of the building which could have enabled slaves seeking freedom to hide without being detected.

An overview article, "A Historical Sketch," was written by Reverend Calvin B. Marshall and was printed in an anniversary booklet, "Peekskill, A Journey Into History, 1839–1965." This article states:

In the mid 1920s the present structure was razed [torn down] *and a full basement with kitchen, rest rooms and dining facilities were added. In 1962 the building was renovated inside and out.*

When the church building was extensively rebuilt in the 1920s from its original structure, it was unclear what structural portions remained from its earlier form.

The church asserts its underground railroad connections in the 1965 article: "Legend tells us that it was occasionally used as an Underground Railroad station by Harriet Tubman." That physical evidence of such underground railroad activities survives within an existing church building is certainly intriguing.

Peekskill's AME Zion Church was located on Park Street in 1852, in the building now occupied by the Church of the Comforter. The AME Zion Church congregation has moved next door into the former St. Peter and Paul's Church on Park Street.

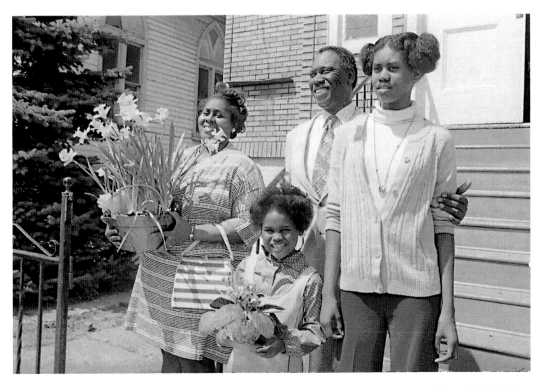

Mrs. Althea and Mr. Howard Philips and their daughters, Elizabeth and Jeanette, stand in front of AME Zion Church on Easter Sunday 1973.

Underground Railroad Tours

Mr. Waymond Brothers and Ms. La Fern Joseph pioneered a contemporary interest in the role Peekskill played in underground railroad activities. The "Sisters in Support" organization has sponsored various forums and free public activities dealing with African American issues.

"Harriet Tubman Underground Railroad" tours feature several local sites such as Park Street AME Zion Church, the former Hawley and Harriet Green house at 1112 Main Street and tunnels at the former Henry Ward Beecher Estate property on Main Street. The tour explains that McGregory Brook was a geographical landmark that ties these locations into an historical and symbolic whole. Thousands of schoolchildren and the public have benefited from these tours.

Five underground railroad conferences were held primarily at Peekskill High School and Westchester Community College. Notable experts sponsored classroom workshops and spoke in the high school auditorium. Peekskill resident Dr. William Sayles, chairman of Seton Hall University African Studies Department; author and Mount Vernon educator Larry H. Spruill; and several other prominent experts in the field were invited guests and speakers. Public education has been the goal of these activities that have achieved considerable media attention.

Tour literature explains that approximately 500 African American conductors assisted in the passage of about 75,000 former slaves through underground railroad networks. Harriet Tubman, named a "Moses" of her people in her antislavery efforts, made nineteen trips into the South to successfully lead 319 people then held in slavery to freedom. Ms. Tubman settled in Auburn, New York, and was aware of Peekskill's vital location for those secretly traveling north to Canada or upstate New York. She was informed of sympathetic citizenry and was likely friends with select local individuals.

A primary effort of the Sisters in Support was to secure the 1112 Main Street property, once owned by underground railroad station agent Hawley Green, as an underground railroad museum. The museum would feature tours, displays and meetings. After years of valiant efforts to secure financing for the long-abandoned building by several people, a focused financial drive by the Mount Olivet Church pastor Reverend Lacey was successful in its immediate goal. He envisioned a Hudson Valley Underground Railroad Museum and Cultural Center.

But in the year 2005, Peekskill real estate values were peaking and costs of rehabilitating the structure to a suitable and appealing level appeared to be formidable. Buying, fixing up the building and then providing operational maintenance, staff and program funding have made such a theme museum a continuing challenge.

Waymond and La Fern were also principal organizers of several Waterfront Green festivals and celebrations with an African American Heritage focus. La Fern Joseph is a founder of the Sisters in Support, which supports various interests, topics and programs relating to African American issues. She was the New York State coordinator for the "Million Women March" in October 1997. La Fern operates the Fern Tree

shop on South Division Street, specializing in African products. While involved with several community projects, working and raising a family, Ms. Joseph was recognized with a Service Award by the Peekskill NAACP in the year 2000.

Peekskill Woman Restored Harriet Tubman's Home

Harriet Tubman performed many important roles for Union forces during the Civil War as a nurse and intelligence agent. Her second husband was former Union soldier Nelson Davis. Friends and supporters of Ms. Tubman, including former governor William Seward, donated a house to her in Auburn, New York, in 1857. Harriet Tubman lived there until her death in 1913. The property later expanded to twenty-six acres and was willed to the state AME Zion Church organization after her death.

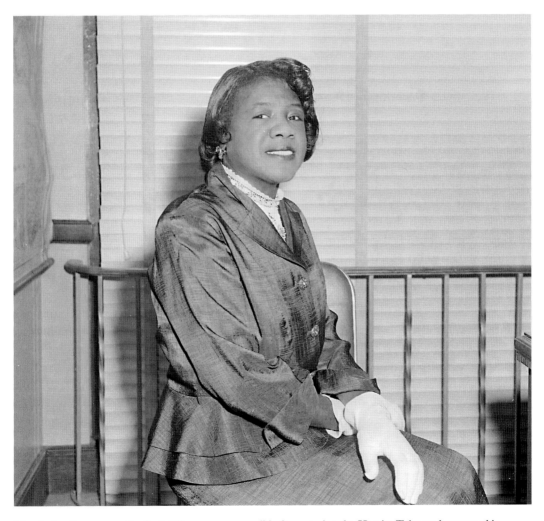

Mrs. Indus Greene was the Peekskill woman responsible for restoring the Harriet Tubman homestead in Auburn, New York.

Mrs. Indus Elizabeth Greene of Peekskill was selected to head a committee that led to the restoration of Harriet Tubman's home in 1953. The historic site helps remind us of Harriet Tubman's accomplishments during slavery, underground railroad and Civil War days.

Mrs. Greene filled several important administrative jobs with the regional AME Church and was vice-president of the Peekskill NAACP in the 1950s. She was also a member of the Field Library board of directors. Her husband was Charles James Greene, and their daughter Juanita Jackson was a Juilliard graduate. Hers is a featured biography in Chester Smith's book, *Who's Who In Peekskill*.

Reverend Beecher and Harriet Made Their Contributions

Peekskill was a home to Reverend Henry Ward Beecher, the determined and powerful antislavery minister. Starting as a part-time summer resident in 1859, he remained associated with this village until his death in 1887. His original large, wooden mansion, built in 1878, still exists in a modified masonry form on East Main Street.

Reverend Beecher was a radical abolitionist in his efforts to end slavery where it existed in the United States. He was an active ally to John Brown during the Kansas crisis of the 1850s. Nationally famous, he lived thirty years on his East Main Street property. Beecher was one of the country's leading antislavery voices during the Civil War era.

Reverend Beecher spoke publicly of sending shipments of rifles to antislavery advocates in Kansas, where the issue of slavery's legalization would be decided by popular vote. When his supporters stamped their shipping crates containing Sharps rifles as "Bibles," these weapons became known as the famed "Beecher's Bibles." Reverend Beecher staged real freedom auctions inside Plymouth Church in Brooklyn. Worshippers would buy an individual's freedom by offering donations toward the purchase price of a person or group of people.

These sensational events led to at least two former slave people settling in Peekskill after such an auction process in 1860 or 1861. An enslaved woman named either Sarah Churchman or Sarah Scheffer and her two-year-old son saw their freedom purchased at an auction inside Henry Beecher's church. In N.A. Shenstone's book, *Anecdotes of Henry Ward Beecher* (1887), we read the following:

> *After she was free, the ladies of the church wrote a little book in which a full account of her life was given. With the money they obtained from its sale, they bought a little place for her [Sarah] at Peekskill where she raised chickens, sold eggs and butter for a living… She never married and was never tired of talking about how good Mr. Beecher and his family had been to her.*

Fannie Virginia Casseopia Lawrence was photographically identified as "redeemed at age 5 in Virginia." She was baptized by pastor Beecher at Plymouth Church,

Brooklyn, in May 1863. That Reverend Beecher assisted runaways in Brooklyn or here in Peekskill seems very much a part of his character, practice and belief.

Henry's sister Harriet Beecher Stowe was the author of the influential bestselling 1852 novel *Uncle Tom's Cabin*. Harriet and Henry shared moral values and often assisted each other's writings. Harriet lived in Connecticut with her family.

Local Union Soldiers

About twelve Peekskill African American men served with Union regiments during the momentous Civil War between the Northern and Southern states from 1861 to 1865. Two of these veterans lost their lives during their military service.

These distinguished African American individuals rose to the challenges of hazardous combat at a time of national crisis. They volunteered or were drafted and then went off to war. The population census of those years listed sixty-nine "Negro males" as residents.

Frederick Douglas made the issue of black military service very clear:

> *Liberty won by white men would lack half its luster. Who would be free themselves must strike the blow. Better to die free than live slaves…This is our golden opportunity. Let us accept it, and forever wipe out the dark reproaches unsparingly hurled against us by our enemies.*

The mention of names and units only suggests each person's intense experiences during those tragically dramatic years in American history. The local Grand Army of the Republic organization of Civil War veterans assembled listings of those who participated.

Two Peekskill "colored" men, according to the wording of that time, sacrificed their lives for the Union antislavery cause. Private Joseph H. Halsted, listed as "colored," died during fighting at Deep Bottom, Virginia, in 1864. He served with the 30th New York Infantry Regiment. Private John W. Knapp, "colored," died in 1863 at age twenty-three. His unit was the 29th Connecticut Regiment. He rests at Van Cortlandtville's Hillside Cemetery.

William G. Green, who was Hawley Green's son, served as a corporal in Company B, 11th Regiment of Heavy Artillery. He returned to Peekskill and lived to be fifty-nine years, six months and fifteen days old. He is buried alongside his mother and father in Hillside Cemetery near the large Civil War cannon.

The patriotic instincts of the Peterson and Moshier families were represented in the conflict by Private John Moshier, who served with the Third Regiment Colored Infantry. He died in 1888 at fifty-seven years of age and is interred at Van Cortlandtville's Hillside Cemetery. Ebenezer Peterson saw military action with the 26th Infantry Regiment as an army private and is buried in Yorktown.

Union regiments were grouped by race, with separate "colored" units performing military operations. Made famous by their daring exploits in the film *Glory*, two local men were soldiers with the 54th Massachusetts Regiment of Volunteers.

Sergeant Joshua Crawford was a veteran of that 54th Regiment. He returned to Peekskill after the war and died in 1877 at age forty-seven. This Crawford family lived at the corner of Grant Avenue and Lincoln Terrace. Private George Butler also served with the famed 54th Massachusetts Regiment, returned home and later died in 1885.

Father and son or brothers were sometimes represented. Charles B. Aray was a corporal in the 29th Colored Regiment. He survived the war and died in 1876 at age thirty-five. He lies in Van Cortlandtville cemetery. Henry A. Aray was sergeant in 20th Regiment. We can place the Aray family on Main Street in 1875 with a listing of Mr. George N. Aray, who worked in the Peekskill stove factories.

Also performing dangerous military service was Hiram B. Hutchinson as an army private. The 1875 Peekskill Directory lists "George Hutchinson, colored," working as a waiter and living in a house at Main and North Division Streets. Benjamin Purdy was another local African American Civil War veteran. "Emeline Purdy, colored widow of George," worked in laundry and lived on Washington Street near South Street, according to an 1875 directory source. It appears they were of the same family.

"Joseph Keyser, colored, laborer," lived on James Street near Brown Street in the year 1861. His name also appears on the military draft list for 1863. George Sickles was a Civil War veteran who raised his family in their Lincoln Terrace home. His wife afterward received a twenty-five-dollar-per-month pension for his military service.

Other Peekskill residents on the 1863 "List of Drafted" were identified as "col'd" (without indication of what colors these people might be). They may or may not have served in the military due to various exemptions offered at that time. These were: John E. Alaire, Alex Cornell, Charles Williams, Henry Ray, Clack Nelson, Frank Moshier, Samuel Gager and John Duey.

Former Southern Slave and Civil War Leader Settled in Peekskill

An important slave memoir was printed in Peekskill in 1922. The document has only recently received the wider recognition it deserves and is now part of our national literature. William Henry Singleton's *Recollections of My Slavery Days* was first published as a booklet by Peekskill's weekly newspaper, the *Highland Democrat*.

The writing is Mr. Singleton's first-person account of his painful experiences with slavery in North Carolina, his military service with the Union army and his fulfilled life while living here in Peekskill, New York. This dramatic and revealing life story was republished and annotated with notes in hardcover by North Carolina's Division of Archives and History in 2001. Singleton's narrative *Recollections* has been used in several published researched projects.

The Peekskill resident offered a clear, honest and complete firsthand account of an American who was sold and resold while living in a Southern state before the Civil War.

William Henry Singleton's published memoir, *Recollections of My Slavery Days*, is now part of the national literature on this topic.

Only in America could a person, within his lifetime, be treated as a piece of property, successfully fight for his freedom with a military regiment and become an author and outspoken patriot.

Consider William Henry Singleton's childhood. At age four:

> *I was sold off the plantation away from my mother and brothers with as little formality as if they sold a calf or a mule. Such breaking up of families and parting of children from their parents was quite common in slavery days, and was one of the things that caused much bitterness among the slaves and much suffering, because slaves were as fond of their children as the white folks.*

Writing of the Southern plantation:

> *Most of the work in the South in those days was done by slaves. Slaves were "ginners," that is they knew how to run cotton gins. They were carpenters, blacksmiths, ship*

Mr. Singleton lived and worked in his own free-standing house at 759 Elm Street just behind this large corner house at Elm and Depew Streets.

carpenters and farmers. An ordinary slave sold from $500 to $700. But a slave of good stock who was a carpenter or a good ginner would be worth from $1,000 to $1,500. When such a slave got on a plantation, he would not apt to be sold. They would keep him on the plantation to do their work.

Singleton narrates with stunning detail:

A slave like that would have a wife, and would be of higher standing among the other slaves. But his children of course would belong to the master, and he would have no legal right to keep his wife if his master chose to take her away from him. A slave that was lazy or shiftless or inclined to run away would not be wanted on a plantation, and sold for almost nothing.

After being sold for the first time as a child:

I did not have any bed to sleep on, simply slept on the dirt floor by the fireplace in the house like a little dog. My mistress had a great habit of whipping me. Some slave owners have a custom of whipping their slaves frequently to keep them afraid. My mistress had a bundle of twigs from a black walnut tree she used to whip me.

At age seven, young William ran away to find his mother. After proving his identity to his mother:

We went into the house, and I was telling them about my trip when we heard the patrol coming. The patrols were something like mounted police. They were men who rode around the country, and if they found any colored people off the plantations where they belonged, they would lash them and turn them over to their masters.

My mother had a board floor to her house and underneath that a cellar. It was not exactly a cellar, but a hole dug out to keep potatoes and things that way. When she heard the patrol coming, she raised one of the boards of the floor and I jumped down in the cellar, and when the men on the patrol came in they did not find me. That cellar was my hiding place and sleeping place for three years.

For three years he slept in hiding under the floorboards of his mother's house. He was captured by the slave patrol, which used a trick of placing biscuits on a nearby fence as bait.

No sooner did I go out after the biscuits than I heard a horn blow. Soon I was surrounded and caught. They sold me that time to the overseer of the plantation.

The overseer's intention was to resell Henry:

He paid $500 for me. But when he sent me to my mother's house to get my clothes, I ran into the woods. They tried to find me, but they could not.

These nightmarish experiences approximate those of Anne Frank's family in Holland when they were kept in hiding from the Nazi hunters. Henry's life journey included being severely whipped because his master's son allowed him to carry his book bag from school.

But Edward said I took one of the books out of the bag and opened it. When his father heard that, he said he would teach me better things to do and whipped me very severely. I cried and told him I did not take the book out, then he whipped me all the harder for disputing his word.

Singleton generalized the good and bad of slavery life:

I do not mean by all this that our life was altogether bad. We had enough to eat and we had certain pleasures…One of the worst features of slavery was that the slaves on a

plantation were virtually in prison, that they could not leave the plantation except with the consent of their masters. Then no matter how hard they worked, they had nothing they could call their own. Even their children did not belong to them.

William H. Singleton Joined the Union Army

As political tensions increased between the North and the South before the war, how much news and information was received by those being held as slaves on Southern plantations? Singleton explained their situation in North Carolina: "We knew of course only what we were told, as we could not read or write." Forbidden to read and write, and despite this totalitarian control of information, news began filtering in about John Brown's deeds, the existence of a secret underground railroad and possible escape to Canada.

Mr. Singleton was held as a servant to a Confederate officer when the war started. But when Union General Burnside's forces pushed into that area, Singleton escaped and worked for the Northern army. "I was taken to Gen. Burnside's headquarters and asked the best way to reach the rebels at Wives Forks." He provided such information and went along as a guide on this and other military actions.

Even before the induction and arming of former slaves as soldiers were approved, William Henry Singleton showed leadership in assembling and drilling hundreds of former slaves. While they marched only with cornstalks in the beginning, they were preparing to fight for their freedom when the cornstalks became rifles.

An amazing event took place one day at General Burnside's headquarters. Singleton describes this as "one of the great experiences of my life." President Lincoln was visiting this important Union army war camp headquarters. General Burnside introduced Singleton to Lincoln with the words, "This is the little fellow who got up a colored regiment." Lincoln responded warmly, and they had some conversation regarding Southern blacks joining the Union army to fight for their own freedom and to crush the system that denied those rights.

Singleton jumped at the opportunity and was soon appointed a sergeant in the 35th Regiment, United States Colored Troops. The officer leading the regiment was James Beecher, brother of Reverend Henry Ward Beecher. An estimated thirty-eight thousand African American soldiers died in Civil War service.

W.H. Singleton saw action as a Union soldier in several states, suffered a leg wound and received an honorable discharge. He moved to Connecticut and then to Maine. He resettled to Peekskill in 1906, where he stayed until 1924. While living here, his important memoir was published as a booklet by Peekskill's *Highland Democrat* weekly newspaper.

William Singleton became a traveling preacher with the AME Zion Church. While living in Peekskill, he joined the Mount Olivet Baptist Church. He was employed as a caretaker in Peekskill by George Buchanan, the owner of a large textile factory. The

large George Buchanan family house still stands on the corner at 200 Depew Street. William Singleton lived in a separate house just behind the Buchanan place at 769 Elm Street.

This African American Civil War veteran was a frequent speaker at patriotic events, and he states in his booklet:

> *When Election Day comes, I go to the polls and vote, and my vote counts as much as the richest or best educated man in the land... My heart is overflowing with gratitude when I think of my situation and the situation of the people of my race now, and think of all the blessings we enjoy compared with our former situation.*

Mrs. Jackson in her memoir, *My Memories*, related her personal experiences with the "colonel," as he was called. She mentioned that Singleton was a tall sturdy man, "and when he spoke of slavery, he shed tears." Sergeant Singleton attended the grand gathering of Union and Confederate veterans at Gettysburg, Pennsylvania, in 1936, and then passed away two years later.

Local Response to New York City Draft Riots

Extreme rioting broke out in New York City in reaction to the first national "draft," or requirement for military service, in July 1863 during the Civil War. Frenzied, drunken mobs destroyed the draft centers, burned several other buildings and challenged and overwhelmed New York City Police. Rioters stole weapons from a local armory and threatened total chaos.

The mob violence turned against African Americans, inciting several lynching incidents. Parts of the mob burned down a large Negro orphanage, the Colored Orphan Asylum, and then attacked those who were trying to escape. Four days of such murderous violence required thirteen Union army regiments to subdue the participants.

More than a thousand New Yorkers were killed during the four days, mostly civilians and many blacks. This incident prompted the construction of numerous armories all around Manhattan, not so much to protect against invaders, but rather to protect against any future violence or insurrection by New Yorkers as seen in the July 1863 events.

What was the local reaction to the New York City draft riots? Peekskill's primary weekly newspaper, the *Highland Democrat*, responded with a well-worded editorial comment:

> *Let us have no outrages upon the persons and property of our colored population. They have done nothing to invite or provoke violence.*
>
> *They constitute a decent, orderly class who have taken no part in the disreputable manifestations made in their name. They are helpless and suffer from inequality of their condition to deserve the protection of the masses...Let Peekskill maintain its reputation as a peaceable and law abiding village. Whatever is wrong, can be righted more speedily and more easily than by mob violence.*

Peekskill village officials also recruited citizens to "enroll themselves as a special Police or Guard for the protection of lives and property." Village officials warned:

> *It is not improbable that Peekskill may be visited for arson and plunder by lawless persons in such force as to render the ordinary police and military organizations of the village powerless for their prompt suppression.*

There were no attacks against African American citizens here. The combination of a sympathetic newspaper editorial and the call for special "Home Guards" to prevent any such violence from spreading was successful. It is interesting to note the perceptive description of the local "colored population" as a "decent, orderly class," who "suffer from inequality of their condition" in the year 1863.

Abraham and William Hallenback

Other personal experiences that confirm the once desperate situation of former Southern slaves include the story of the Hallenback brothers, William and Abraham. Peekskill historian Chester Smith once wrote that "William was a veteran of the Civil War." One year after the end of that horrible national conflict, in 1866, the brothers arrived at the Annsville Creek inlet in a small barge or boat they nicknamed "the Ark."

The brothers lived for some years inside their ark/boat as a home. The brothers later lived in a cabin built near the water. They kept themselves busy fishing and doing various jobs for the remainder of their lives. William and Abraham Hallenback became friendly with Peekskill residents. The brothers' location on Annsville Creek became a local swimming spot. They provided watchful eyes and guidance for many boys who came to swim for the first time. They also showed the youngsters ways of handling small boats and how to catch fish and crabs in the creek.

In recognition for their many years of gentle service to this community, a bronze memorial plaque inset in stone was placed along the Bear Mountain Extension Road on a hillside overlooking Annsville Creek. This memorial to Abram and William was recently relocated to Annsville Park in a setting more visible and closer to the shoreline.

The plaque's words recognize the two brothers, who, by their help and watchfulness, were a center of the creek recreation area. The memorial reads: "From 1866 to 1904 the Favorite Playground for Three Generations of Peekskill Boys." This enduring reminder of our history is now at the water's edge along Annsville Creek.

Abraham was a member of St. Peter's Episcopal Church on North Division Street. "Abram" made Annsville his home until he passed away in 1904 at age seventy-six. He is buried in Van Cortlandtville Cemetery with his brother.

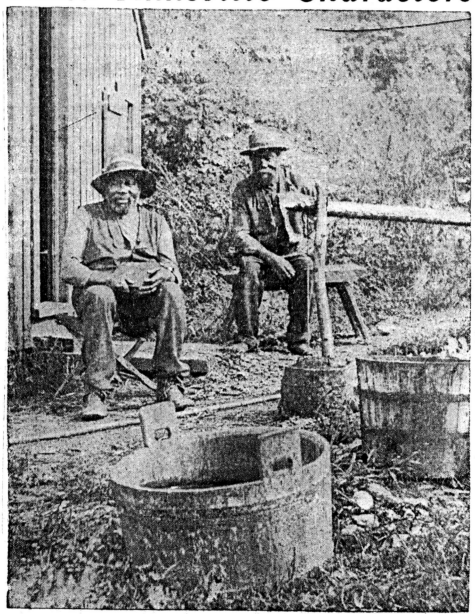

VOL. XVIII—NO. 195 PHONE 1200 Member of Associated Press
STAR: AUGUST 19, 1944.

Abraham and His Brother Once Noted Annsville Characters

Taught Hundreds of Peekskill Boys How to Swim in Creek Near Their Shack

Abraham and William Hallenback were brothers who settled at Annsville Creek after the war. William was a Civil War veteran. A bronze plaque to their memory is located at the new Annsville Park.

William Tinsley: Peekskill Success Story

An interesting newspaper article and photo focused on William Tinsley in the June 12, 1945 issue of the *Evening Star*: "Bill Tinsley Dies; 91-Year-Old Ex-Slave Well Known Locally." This interesting resident was featured in the article, with an inset photograph

'Bill' Tinsley Dies; 91-Year-Old Ex-Slave Well-Known Locally

June 12 '45

William Tinsley, retired employee of Standard Brands, Inc., and one of the last remaining pre-Civil War slaves, originally from Virginia, died this morning at the home of his son, John Tinsley, of 1014 Man Street, at the age of 91.

"Bill", as he was known here, was liberated as a slave when he was 12 years old. He had been in failing health for the past six months, and was quite seriously ill since February. He had been employed by Standard Brands, Inc., for 25 years.

His wife, the former Eliza Thompson, died nine years ago. The funeral will be held on Friday at 1 o'clock from the Harold Moore funeral home, 729 Main Street, and at 2 o'clock at the Mount Olivet Baptist Church. Interment will be made in Hillside Cemetery.

Mr. Tinsley was born a slave in Ashland, Hanover County, Virginia, on February 9, 1854, and was the son of Joseph Tinsley and Frances

William Tinsley

An interesting newspaper article and photo focused on William Tinsley in the June 12, 1945 issue of the *Evening Star*.

showing a strong elderly black man looking straight at the camera. When we read the story, it turns out that William Tinsley, who was born in 1852, made an extraordinary success of his life after being liberated from slavery at age twelve in Virginia during the Civil War.

Bill Tinsley retired after twenty-five years working with Standard Brands Company, or Fleischmann's as it was always mostly identified, where the RESCO incinerator is now located at Charles Point. He lived with his wife Eliza and children at 1347 Howard Street. He relocated to Peekskill in 1888 and followed his father's trade as a mason and bricklayer. "Mr. Tinsley was well known here and had a host of friends," the article reports.

Mr. Tinsley had fourteen children by two wives. In addition to his two brothers and two sisters, his ten grandchildren, nieces and nephews survived him. The first twelve years of Tinsley's life, though he was enslaved, were not terrible:

> *He was so young at the time of the war that he never experienced the life of a slave. Rather he was permitted to run about the grounds of the spacious estate, and fortunate in being the property of a gracious owner, he was treated kindly by the family.*

The article explains: "His father, being freeborn, saw service in the Rebel army by being employed to build breastworks." Breastworks were a defensive military barrier built as high as a person's chest and made from all kinds of materials. This is a fascinating American story that gets even more interesting.

> *As it happened, the law in the South declared that children follow the fate of their mother. Mr. Tinsley's mother was a slave and consequently her nine children were destined to be subject to a white master despite the fact that her husband, Josephius Tinsley, was a free man, having become so by his mother who was an Indian squaw and consequently regarded as a free woman.*

Where else in the world could such a textured family history develop as in America? Bill Tinsley died inside his son's home at 1014 Main Street in June 1945. The funeral service was held at Mount Olivet Baptist Church, where he was among the original founders. He now lies at Hillside Cemetery in Van Cortlandtville.

The Peekskill directory of 1935 lists Bill's son John T. Tinsley as living at the Howard Street address and working in the kitchen at the Forbush Hotel on South Street where Wesley Hall apartments now stands. Lucille was also living at the Howard Street home at that time, as well as Joseph who was a "pugilist" or professional boxer. Ms. Irene Jones is his granddaughter. Further interesting details on the extensive Tinsley family are available in Ethel Jackson's memoir, *My Memories of 100 African American Peekskill Families.*

Work, Family and Churches in the Late 1800s

Peekskill and surrounding Cortlandt were home to a number of African American residents who had endured slavery for generations. Some Americans of African descent who displayed successful efforts during the Revolutionary War also made their homes in Peekskill and Cortlandt.

Some local African American citizens in Peekskill assisted refugees from Southern slavery via the underground railroad escape routes. Several others joined Union army regiments to help end slavery and affirm the country's better values. The Green family of Civil War and underground railroad times carved an enduring legacy of positive influence in the community. Others worked at the edges of the community in low-paying jobs and made only small progress after several generations.

After the terrible Civil War, Americans of all kinds pretty much got down to business as they saw it. Black-skinned Americans worked on the stone-and-earth aqueduct systems that delivered fresh water from the Croton watershed area to New York City. Many black citizens worked in the Hudson Valley brick industry in the late 1800s. An excellent source is *Within These Gates*, a book by Daniel de Noyelles. Photographs reveal that about a third of the brick makers working at Haverstraw companies were African Americans. The author indicates that Southern blacks would come north for the seasonal brickwork that shut down during winter.

People of African origins worked in Hudson Valley iron industries, became railroad and steamboat workers, opened businesses, raised families and became educated as best they could. Most work was done by hand or was very labor intensive, even when assisted by machines.

This generation generally did the things that one needed to do in the years before electricity, power tools and motor vehicles. Peekskill directories provide yearly listings of every resident in alphabetical order by their last names, occupations, business and home address. White people are not designated, but black or African American residents are specified by a "colored" or "(col'd)" description after their names. This local information tells us who was of African descent, what work they were doing and where they lived.

The range of occupations was typical of that era. Joseph Gaston worked as a barber, with a residence on Central Avenue (then named Center Street) in 1875. Thomas Hicks was a "soapmaker" while living at James Street near Brown Street. Another listing recorded: "Henry C. Hicks (col'd) saloon, Diven, h [house] James n [near] Brown." George N. Aray then worked as a "driller, stove works," and resided on Main Street. Joseph Keiser was a butcher living on Central Avenue near Water Street in 1875. Peter Moshier, a "hostler," ran or worked at a hotel on Park Street, while living on Crompond Road near Academy Street.

When horses and carriages were the transportation as much as gasoline cars and trucks are today, we can understand people working as teamsters, grooms, drivers or in livery stables as did African American residents Charles Leggett, Lewis Oliver and Albert Thompson.

The James Pollet family in 1875 has three listings: Mrs. Elizabeth Pollet "(col'd)" worked at the Peekskill Laundry while living on James Street at the corner with Park Street; Reuben Pollet was a gardener; and Richard was a laborer living at the same address.

The Peterson family has five separate 1875 listings: Charles Peterson was a clerk on Division Street while living on Diven Street; George was a driver with a house on James Street; another George Peterson worked at a hotel on Maple Avenue near Crompond, where he lived; Pierre is listed as a farmer living on Central Avenue; and laborer Willet Peterson lived on James Street.

Also listed was "Henry A. Ray (col'd) laborer, h Belden n Hadden." Jarvis Ray lived on Diven Street in the same house with Sarah Ray, a widow of Abram. Benson Ray was boarding on Main Street in 1875 while working as a "groom." Abraham Jackson worked as a laborer and lived along Central Avenue. Henry Wright was employed as a cook while living on Main Street.

An interesting look into the numbers of Peekskill's "colored citizens" was made by a local newspaper in 1870. A *Highland Democrat* newspaper article directly named Hawley Green as an influential political organizer:

> *The colored population, now the right arm of the radical party in this village, at the Judicial election on Tuesday last cast 43 votes. The most active Republican was Hawley Green who was earnest and active in bringing forward his sable brothers to the ballot box.*

Peekskill's business directory publication for the years 1889–90 lists a full-page advertisement and a graphic portrait of Professor T.A. Beckam. Clearly a man of African descent, Mr. Beckam was an announced "Professor of Dermatology and Barber-surgeon" who offered "Special Attention to Head, Scalp and Skin Diseases…white and colored, male and female" at his Central Avenue downtown shop. Barbering was just one of his business ventures. Professor Beckam also offered: "Money to loan on personal real estate and investment. Residences, cottages, farms, lots for sale, trade or rent." His shop also provided messenger service, telephone service (a brand-new invention at that time), telegraph and mail orders.

T.A. Beckam's shop also had cigars, pipes and snuffs for sale. The "Grand Central Shaving Saloon" was located at 926 and 928 Central Avenue, Peekskill, New York. It is curious how past and present sometimes connect. Charles Hicks's retirement was featured in a 1944 *Evening Star* photograph and article. He was retiring after fifty-nine years working as a Peekskill barber. Mr. Hicks and his wife Ada Tallman lived at 1260 Academy Street. Where did Charles Hicks, at age seventeen, first learn the trade that would employ him until 1941? At Professor Beckam's multiservice Central Avenue Shaving Saloon, of course!

Charles Hicks was born in Putnam Valley in 1865. He and wife Addie Anne Victoria Tallman had seven children together. He was an active Mason. Upon his death, Masonic services in his honor were held at Park Street AME Zion Church. He

28

Prof. T. A. BECKAM

United States and Hudson River

EMPLOYMENT AND REAL ESTATE BROKER,

AND MESSENGER OFFICE.

Grand Central Shaving Saloon

DEALER IN

Imported and Domestic Segars, Tobaccos, Pipes, Snuffs,

Cigarettes, Notions, &c.

Special Attention to Head, Scalp and Skin Diseases. Decay and Gray Hair, Dandruff, &c., promptly cured. Servants and Situations supplied, white and colored, male and female. Residences, cottages, farms, lots, &c., for sale, trade and rent. Money to loan on personal real estate and investment.

MESSENGER OFFICES. Confidential Uniform Boys to transfer Parcels and Messages to any part of the County.

Prompt Attention Paid to Telephone, Telegraph or Mail Orders.

P. S.—Private Parlor for Ladies' Hair-cutting, Shampooing, &c. Switches, Braids and Wigs made and repaired from the Individual Hair or Combings.

T. A. BECKAM, Prof. of Dermatology and Barberchirurgeon.

926 & 928 Central Avenue, - - PEEKSKILL, N. Y.

P. O. Address, Box 780.

This is a graphic of Professor T.A. Beckam in the *Peekskill Business Directory* for 1889–90.

Charles Hicks, as seen at the time of his retirement in 1941 after fifty-nine years of barbering.

lies in Hillside Cemetery at Van Cortlandtville. He and his son Charles H. Hicks Jr. operated a successful taxicab business on Brown Street with a fleet of well-kept cars for many years.

Mount Olivet Baptist Church

As Peekskill businesses expanded and jobs were available at the end of the 1800s, residents recognized the growing community's religious and spiritual needs. A small group of like-minded people began meeting for prayer and reflection at a private Main Street home in 1893. Archer and Jane Clayborne, Mrs. Mary Fipps, Mrs. Eliza Tinsley and Mrs. N. Ward are people associated with those first prayer meetings.

Those meeting soon grew into a congregation that decided it wanted its own Baptist church with a pastor to guide its members. The Baptist Church of Peekskill was officially incorporated in 1901. Mr. William Wortham, Wyatt and Sarah Bagley, Philander Peterson and Ross Walker joined the first congregates in this important step.

Mount Olivet Baptist Church as it appeared in 2007.

The renovated Mount Olivet Church was dedicated on December 13, 1965. Reverend G. Franklin Wiggins is at left, Reverend Richard H. Puryear is at center and Reverend Carl B. Taylor is at right.

The next important steppingstone was the construction of a church building. With land acquired on Southard Avenue in 1907, a new building appeared in 1910 under the direction of Deacon James Hankins. Mount Olivet Church has ever since experienced a series of expansions of social and spiritual activities and outreach programs, as well as extensions of the physical structure. The Young People Helping Hand Club was formed in 1930.

Many excellent commemorative booklets marking milestones in the church history were published through the years as excellent sources of reference. Mount Olivet Church celebrated an anniversary in 1956 with a booklet that listed its officers and helps remind us of those who helped drive and shape the institution through the 1950s and '60s. The church pastor at that time was Reverend Carl B. Taylor. The assistant pastor was Reverend James Smythe. Frances Hobson and Henry Tolliver were statisticians. Mrs. Harnetha Lewis directed religious education. Other familiar names listed are Sinclair Bynum, Lawrence McKinney, George Jackson, Eugene Jackson and James Hankins.

The many smiling faces of the young "Petites" brighten this group photo at Mount Olivet Church in April 1970.

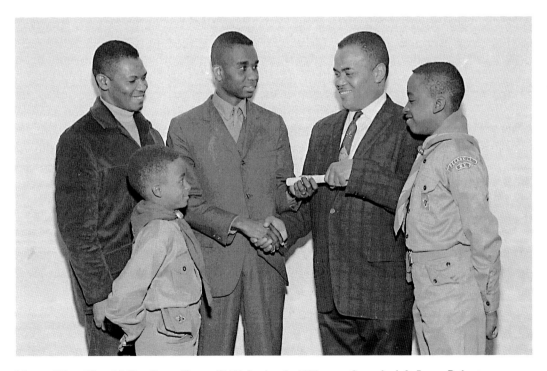

Mount Olivet Church's Boy Scout Troop #140's leaders in 1970 were, from the left: James Roberts, Scoutmaster William Bryant and Robert Duke holding the troop's charter.

Wise, dedicated and caring pastors worked to build a strong congregation through several decades. With the arrival of Reverend G. Franklin Wiggins in 1960, a new expansive era began. Reverend and Mrs. Wiggins's important contributions are detailed in a later section of this publication.

John Duey and General Pomeroy's Sword

John Duey was an African American man living on Water Street in Peekskill after the Civil War. While he may have seemed an ordinary person for most of his life, one day he made an exceptional discovery that reached back to Peekskill's important role in the Revolutionary War and made big news.

Mr. Duey was a local laborer and "brick burner" who sometimes worked digging graves at Van Corlandtville cemeteries. While at his cemetery work, he unearthed a large military sword once owned by an officer from the Revolutionary War. Surprised to find such an impressive and perhaps valuable item, Mr. Duey thought he might be accused of grave robbing.

So he took the historic relic to his home, where he kept it for forty years. Before he passed away in the early 1900s, John Duey confided in several responsible Peekskill citizens and gave them the historic sword. Upon examination, it turned out that the Continental army sword likely belonged to General Seth Pomeroy, who died at Peekskill in the winter of 1777 and was buried in an unmarked grave near Old St. Peter's Cemetery. It just so happened that General Pomeroy was an officer in charge at the battle of Bunker Hill in Boston Bay in 1775.

While on his way to join General Washington's forces in New Jersey, Pomeroy, then seventy years of age, died of a lung infection inside a Peekskill Main Street home. The general's body was escorted with a military procession from Peekskill to Van Cortlandtville. He was buried in a yet unmarked gravesite near the Little Red Schoolhouse off Locust Avenue, once the location of a former Baptist church.

In response to the national patriotic feeling generated by the War of 1898 with Spain, a thirty-feet-high polished stone monument to General Seth Pomeroy was dedicated at Hillside Cemetery. A few years later, gravedigger John Duey revealed he had accidentally uncovered General Pomeroy's military sword. The discovery made news in 1907, when the sword was ceremoniously returned to General Pomeroy's family in Northampton, Massachusetts.

Unheard Voices on the National Scene

World War I: Buffalo Soliders

The United States joined the fighting in Europe during World War I in 1917. Despite racial segregation of military units, 350,000 African American soldiers were part of that expeditionary force. "Buffalo Soldiers" was a name given by Native American tribes to the black cavalry soldiers they saw in the west after the Civil War. The 9th and 10th Cavalry and the 24th and 25th Infantry were organized as African American units in 1866. Their legacy carried over into World War I.

George T. Jackson of Peekskill served in Europe as an army corporal in the 92nd Buffalo Infantry Division from 1917 to 1919 during World War I. The unit also served in combat during World War II. Jackson experienced eight months of warfare in France, Belgium and Germany, participating in battles at the Argonne and against the Hindenburg line.

Born in Virginia, Mr. Jackson became an officer with the Peekskill Housing Authority, which sponsored the building of the Dunbar Heights apartments. He was also an active member of Mount Olivet Baptist Church, the American Legion and the NAACP. He was grandfather to former mayor Richard E. Jackson Jr.

1900 to 1940: Modern Life, Hopes, Setbacks and Anxiety

John Green worked on Wall Street during the financial panic and collapse of 1929. The former Diven Street resident worked for local broker Richard Rixon. Mr. Green's job as a "boardman" was to transfer stock listings from a ticker tape onto a larger visible board.

The Peekskill resident recalled his experiences to writer Kathy Daley in the *Herald*:

I remember seeing customers wiping their foreheads, wringing their hands as they turned from rich to poor in minutes. There was bedlam in the streets as people found their whole life savings had gone down the drain.

The stock market crash of 1929 was a turning point into economic difficulties that were not relieved until the United States entered World War II in 1941.

An interesting item appeared in a 1915 Peekskill newspaper about the Savoy Restaurant on Main Street. The specialties were oysters on the half shell, oyster stew and raw oysters. The restaurant also offered catering. It seems that Mrs. J.A. Moshier returned as the Savoy owner and this was newsworthy.

Frank Moshier, his son Frank Moshier Jr. and grandson Harold worked at the Southard-Robertson stove foundry on Main Street at the same time. The notable fact that three generations of this one family were employed at the local industry was featured in a 1917 newspaper article with a photograph. Born at Peekskill in 1840, Frank Sr. lived on Lincoln Terrace and had nine children. The article reports:

The senior Moshier has two other sons, George and Chester, who also worked at the Southard-Robertson foundry. They are all stanch Republicans in politics, industrious men, excellent citizens.

The years 1920 to 1935 saw dramatic events that shook the lives and confidence of many Americans. While World War I was a military success, many veterans were seriously changed and damaged by that awful war.

Those who tried to find relief in alcohol met new laws that made buying, serving and drinking alcohol illegal. A terrible influenza (flu) epidemic quietly and randomly killed millions of people. Wall Street financial speculations led to a devastating business collapse, massive unemployment and poverty. And there was no social security or unemployment compensation in those times.

During a tremendous burst of industry and invention that swept across this land after the Civil War and into the World War I years, most Americans saw their daily lives change dramatically. Electric lights and pumps, automobiles, radios, sewing machines, typewriters, toasters and vacuum cleaners were accepted by most Americans with amazing ease. This was also the beginning of the Harlem Renaissance, when local musicians such as Lloyd Wortham performed in quartets in New York City. James W. Hankins gave a dedication speech for the Lincoln Exedra in 1925.

Electric power plants, central heating, steam and combustion engines, telegraph, telephone, light bulbs, bathroom plumbing, electric trolley cars, gasoline-powered cars and trucks, phonographs and movies and even airplanes all appeared within a few amazing decades centered around 1900. Peekskill built one of the earliest complete electric trolley systems. Workers came from outlying areas of Mohegan, Putnam Valley, Buchanan and Verplanck that were connected by thirteen miles of trolley tracks. The Peekskill Lighting and

Leaders of Boy Scout Troop #21 met at the Ringgold Street school cafeteria in May 1940. Seated, left to right, are Arthur Hopkins, Reverend Conrad and Red Rivers. Standing are Francis Carter, Charles Spicer and J. Melbourne West.

Railroad Company generated its own power from the red brick buildings still standing on Water Street, just north of the lower Main Street intersection.

Quite a few African American men worked as laborers on the massive Bear Mountain Bridge and Road project in 1923 and 1924. Blasting the three-and-a-half-mile access road from granite bedrock at steep angles from Annsville to the bridge was a very difficult task. The stone had to be drilled and removed piece by piece without dropping down onto the railroad tracks below. Bear Mountain Bridge was the first such crossing for cars between Albany and New York City.

Inventions of more mechanical and electrical things led to more factories to make these items, and this allowed for more jobs. Blacks and whites tried to get a piece of this working-class prosperity. Economic conditions in the Southern states remained largely stuck in the past, especially for African Americans. They endured a new form of stuck-on-the-land slavery in an agricultural share-cropping system that prevented prosperity through labor and enforced racial separation for most daily activities.

These obvious underlying injustices, inequalities and tensions grew steadily and silently within the country. Lynchings of blacks by whites for real and imagined offenses seemed to be tolerated in many areas as vigilante, or Klan, justice.

A curious racial backwardness developed within the United States during the early and mid-1900s. The notorious Ku Klux Klan received more popular attention and

The Royal Taxi service was operated from 1940 to 1950 by brothers William and Rayford Roberts. Eddie Buffalo was the driver standing beside a taxi.

influence around the country. The Klan's popularity may have been a fad, but its effects persisted into most of the 1900s.

Peekskill experienced the arrival of several black families from the Southern states during the 1920s, '30s and '40s. Among these were the Tapleys, Bynums, Johnsons and Fullenweiders, all of whom soon became business and social leaders within the wider community.

Peekskill Ku Klux Klan Sets Its Stage: The 1920s

In July 1925 the Peekskill and Cortlandt area experienced one of the largest Ku Klux Klan rallies ever held in the Northeast. An estimated twenty thousand participants in seven thousand cars showed up from New York City, New Jersey and Connecticut to gather on a fifteen-acre field off Lafayette Avenue near Maple Avenue, just within the Town of Cortlandt border.

Peekskill's "Grand Glory Klan #3" hosted this huge event. Band music played for the daytime Sunday picnic as families enjoyed ice cream, a parade, a baseball game and then a Klan induction ceremony for 250 women and 200 men. The evening ceremonies saw thousands of pointed white hoods, full-length robes and capes assemble between two thirty-foot fire-blazing crosses at opposite ends of the field. A huge symbolic fireworks display followed at midnight.

PEEKSKILL KLAN NO. 3, K. K. K., HOLDS BIG OUTING, PICNIC, MEETING AND INITIATION

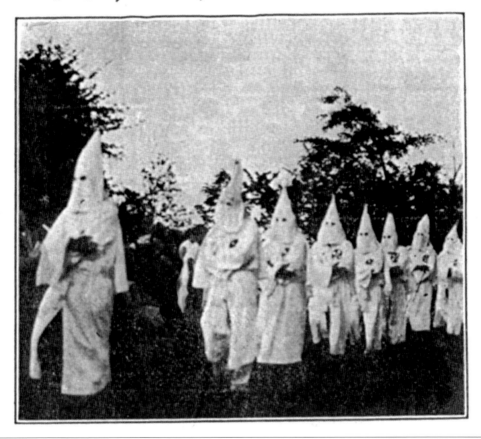

Peekskill Klan No.3 sponsored a huge weekend gathering on Lafayette Avenue in 1926.

It was a contented, orderly aggregation that was present at Peekskill Klan's picnic, else one lone trooper could never have handled the large number of automobiles.

So commented the *Highland Democrat* reporter given special permission to attend and report this event. Some local folks who showed up may have thought the Klan was a lark or a fad, but the result was to infect whole families with twisted views of society.

The Peekskill Klan made news three years later with a 1928 headline: "Rioting at Verplanck's Brings Forty Troopers." At issue was the national presidential election that year, with Herbert Hoover winning over Irish Catholic candidate Alfred Smith of New York. As part of their victory celebration, Peekskill anti-Catholic Klan leaders wanted to burn a fiery cross in St. Mary's Cemetery at Verplanck's Point.

Burning a cross inside a Catholic cemetery was the Klan's way of expressing its feelings about the unsuccessful Democratic Party presidential candidate, Alfred E. Smith. With a strong Irish Catholic presence from brickyard industry days, Verplanck "Pointers" prepared for the hostile Klan caravan rolling in from Peekskill.

Klan cars were ambushed by outraged Pointers. The invading Klan leader from Peekskill was attacked and assaulted. Some Pointers wanted to hang the Klansman from the very cross he proposed to burn in the cemetery.

Another headline read: "Streets Barricaded. Fight Ensues, Cars Wrecked, Blood is Shed." The Klan's talents for provoking violence appeared again at Van Cortlandtville twenty-one years later. The Peekskill Glory Klan held its rallies as family-day events on Lafayette Avenue through the 1930s. A poster from 1932 announced: "Come One, Come All for a real good time at KKK Field Day to be held at Old Klan Field, Lafayette Avenue, Peekskill, N.Y."

World War II Veterans

Military battles against deadly expanding empires in Europe and Asia led by Germany and Japan dominated most other activities from 1941 to 1945. While more than 100 of 2,354 Peekskill and Cortlandt veterans of World War II were of African ancestry, several individuals are notable for their distinctive participation, including those who lost their lives in that international conflict on land, sea and in the air.

American, Canadian, British, French, Russian and Chinese forces worked together to defeat their military enemies in 1945. A campaign popular in African American newspapers of that time was the call for "Double V": victory overseas and victory at home against racism and limitations on daily living.

Donald H. McCrae was among those who did not return from this war. The former Main Street resident was a twenty-year-old infantryman fatally wounded by an exploding artillery shell fragment during battle action in Italy on February 8, 1945.

Private McCrae was awarded a Bronze Star for his heroic battlefield performance, as well as the Asiatic-Pacific Theatre Campaign Ribbon and the American Theatre Campaign Medal. Donald McCrae lies in a marked grave in northern Italy.

Sheldon Craddock, an outstanding athlete at Peekskill High School, was killed in action in the Pacific Islands. Technical Sergeant Craddock was reported missing in action in June 1944. He had been the high school basketball captain and a member of the football and baseball teams. After graduating PHS he was employed in defense work in New York City.

James Elijah Overby, originally from Virginia, was an army infantryman wounded by shrapnel during the decisive D-Day invasion force at Normandy, France, in 1944. Mr. Overby was one of two thousand African American soldiers who were participants in one of the largest invasion forces in the history of the world. He was later employed in the maintenance department at the former Sisters of Good Shepherd operations. His daughters Audrey and Enolia are currently employed in Peekskill City Hall offices.

Jim Cooke (left) and Bill Strumke (right) read the sports page in 1953. Each worked in professional football.

Albert Gaines was one of the renowned Tuskegee Airmen. These were black college students participating in a program to train and produce pilots for the war effort. Despite skepticism that such students could master flying skills, Mr. Gaines completed the course, became a navigator and rose to the rank of army captain. He then became an instructor for other pilots.

After the war, Gaines was a lawyer and computer engineer with IBM, scoring one of the highest results on its exam. He recalls personally meeting the Watson family, who started IBM, and Eleanor Roosevelt, who was an advocate for African Americans becoming wartime pilots. Mr. Gaines became the first African American elected to the Lakeland School Board.

The Tuskegee flight school produced 992 African American fighter and bomber pilots, half of whom saw combat action. The black pilots' 99th Fighter Squadron received a Distinguished Unit Citation in 1945 for shooting down 106 German planes.

Peekskill resident Clarence Moshier was a naval crew member aboard the USS *Mason* during its important contribution to American history. The USS *Mason* was a World War II destroyer escort ship entirely manned by 160 African American naval crewmen. The *Mason* participated in five wartime convoy crossings of the Atlantic Ocean in which it was subject to enemy air and submarine attacks. The ship was outfitted with depth charges, deck guns, machine guns and sonar equipment. It was capable of cruising at

twenty-one knots, a considerable speed for such a war vessel nearly three hundred feet in length.

Charles Moshier served as a driver with the famous Red Ball Express, which supplied Patton's army as it advanced into Europe toward Germany. Convoys of military trucks bringing necessary materials to the moving front lines ran day and night, with priority over other traffic.

Sinclair Bynum was a Buffalo soldier with the 92nd Infantry. This unit continued the tradition of those who served in the American West during the Indian Wars of the late 1800s. The unit shoulder sleeve insignia was a black buffalo on a green background.

Frank Scott was promoted to first lieutenant at nineteen years of age. He served with the 371st Army Infantry. After graduating PHS in 1942, he enlisted in the army and completed officers' training school.

The Peekskill NAACP sponsored a "Welcome Home Dinner, Honoring Those Who Served in World War II" on May 1946. The event program lists those African American citizens from Peekskill who served in U.S. armed forces during that war. Each service was represented: William Amory, navy veteran; James Hankins, army veteran; Percy Peterson, air corps veteran; and Robert Robinson of the marines all spoke of their experiences.

Sinclair Bynum's family members were guests of the Chillicothe Optimist Club in Ohio in August 1969.

Mr. and Mrs. Frank Scott are seen here in Tokyo, Japan, in 1964, while Mr. Scott headed the United States press section. Mr. Scott, who was a military officer, is buried at Arlington Cemetery.

James Hankins was honored by the Peekskill Military Academy for his fifty years of work as chief cook. A large bronze plaque to Mr. Hankins is now in the Peekskill Museum.

Above: Pictured is Sheldon Craddock as a PHS track team member in 1941. He was later slain during military service in World War II.

Left: Charles Bolden was Peekskill's first African American patrolman. He received a Red Cross Award in 1955 for saving someone's life.

Peekskill Mayor Ralph Hopkins was present as awards were presented to Gold Star Mothers Mrs. Julia Craddock and Mrs. Sarah McCrae. The program list includes veterans who were residents and those who later moved to Peekskill:

William V. Alexander
William P. Allsberry
Louis E. Amory
William C.M. Amory
Frank Andrews
Eugene S. Arthur
Robert F. Badger
Joseph Barnes
Charles H. Bolden
Edward T. Branch
John L. Branch
Alexander L. Brown
Marshall L. Brown
Theodore Brown
Lincoln Burns
Grafton Bynum
James G. Bynum
Raymond E. Bynum
Sinclair L. Bynum
Leonard Carrington
Nathaniel P. Carter
George L. Clingman
Alfred E. Cole
Charles Cooper
Sheldon Craddock
Charles Dabbs
Henry Dabbs
James Dabbs
Thomas Dabbs
James Davis
Rex E. Day
Arthur Dennison
Emanuel Diaz
Charles Fauntleroy
William H. Fields
Cornelius Fipps
George Fipps

John H. Fipps
Ordell P. Fipps
John Fullenweider
Albert Gaines
Carl T. Goode
Howard A. Greene
Robert H. Greene
Edward R. Hamilton
Garfield T. Hankins
James H. Hankins
James W. Hankins
Clarence Hatfield
Quentin E. Hicks
John W. Jackson
Pettis Jackson
Reginald Jackson
Richard Jackson
Wiley M. Jackson
Warren N. Jervis
Edward L. Johnson
Vincent Johnson
James Jones
John Jones
Joshua Itlewise
Floyd Keesley
Herman V. Lee
Leroy Lefton
Walter Lockett
John Love
Lester Love
William Love
Donald H. McCrae
James E. McCrae
Cleo McKinney
Edward McKinney
Walter Morris
Charles C. Moshier

Clarence H. Moshier
Melvin W. Moshier
James E. Overby
Oscar Perry
Percy D. Peterson
Stanley Peterson
Marcano Pines
Robert Quamily
Ernest Reed
Harold Reed
Hazell Redd
John Reed
William A. Rich
Robert W. Robinson
Eugene Ruffin
Charles Scott
Frank Scott
James Scott
Lester Scott
Sargent S. Sharpe
Roland Stansbury
Willie Stephens
Robert Taylor
Albert Thomas
Ernest Thomas
John Thomas
David Tinsley
Sylvester Undly
Arthur Washington
John W. Washington
Robert A. Wells
John W. Wells
Bernard West
Norman West
Algernon White
James H. Williams

World War II's "Black Panthers"

"Black Panthers" was a nickname for one of two all-black tank units during World War II. The U.S. 761st Tank Battalion motto was "Come Out Fighting." The U.S. military was strictly segregated by race during World War II. The 761st tankers joined General Patton's forces in Europe. George Patton delivered this welcoming speech to the troops:

> *Men, you're the first Negro tankers to ever fight in the American Army. I would never have asked for you if you weren't good. I have nothing but the best in my Army. I don't care what color you are as long as you go up there and kill these Kraut sons of bitches. Everyone has their eyes on you, and is expecting great things from you.*

This unit led the way in breaking through the Siegfried line of German defenses. They experienced 183 days of constant fighting as American forces pushed into Germany. Men of the 761st met friendly allied Russian forces in Austria that had fought their way from the eastern front.

Paul Robeson Sings in Peekskill: 1947

Though World War II had ended with the successful victory over persistent and dangerous enemies across two oceans at the same time—a victory that Peekskill residents had offered considerable participation and sacrifice to ensure—the constant racial hostilities, bad attitudes and tensions within the United States did not suddenly end in one glorious celebration of wholesome Americanism.

Events near Peekskill tore open the wounds of our racial antagonisms for the whole world to witness. But before we look at the 1949 events at Van Cortlandtville, we should consider the year 1947. A headline in Peekskill's *Evening Star* newspaper on August 25, 1947, read: "Paul Robeson Concert Draws Crowd of 4,000." A Saturday night variety event "attracted the largest crowd ever to assemble in Peekskill Stadium."

The stadium at the lower end of Welcher Avenue was a baseball field where the Highlanders local professional team, once affiliated as a farm team with the New York Giants, was active in the mid-1940s. The stadium was later converted to a fifth-mile oval racing track for older "stock" cars. The area later became a shopping area, with an A&P supermarket and a McDonald's.

An unnamed *Evening Star* reporter gave the Robeson concert a glowing review:

> *The quality of entertainment was without doubt the best presented in Peekskill in some time. Robeson's voice carried well over the loudspeaker system, and he was cheered loudly after each song. There was no denying but that he lived up to the reputation he has earned as a singer throughout the world.*

PEEKSKILL, N. Y., MONDAY, AUGUST 25, 1947

PAUL ROBESON CONCERT DRAWS CROWD OF 4,000

Few Peekskill Residents in Attendance

While the Paul Robeson "variety concert" here Saturday night attracted the largest crowd ever to assemble in Peekskill Stadium, not more than a hundred or so permanent Peekskill residents were in attendance, according to reports from observers. The turnout totaled over 4,000, with spectators jamming every inch of available space in the regular grandstands and overflowing into 1,500 additional seats erected on the baseball infield.

The Peekskill American Legion, in a statement released recently by its executive committee, had "condemned the theory of Communism" it attributed to Robeson and requested city residents to refrain from attending.

There were no political speeches and the entertainment portion of the program included some of the best talent to appear in Peekskill in some time. Alfred Kahn, writer, of Croton, outlined the purposes of the meeting after an introduction by Robeson himself near the end of the program.

Above, the 1947 Paul Robeson concert at Peekskill Stadium was described by an *Evening Star* reporter.

Furthermore, Peekskill police were on hand to handle traffic, and everything went smoothly. The news reporter noted several references to "communism" by speakers. Dorothy Parker, when introduced, said, "I hope you don't think I'm going to be communistic." Another speaker made a connection between the situation of Jews in Palestine and blacks in the South. Event organizer and writer Alfred Kahn of Croton stated, "We're all Americans, and believe in freedom of assembling. We all believe in democracy." This big, successful concert featuring Paul Robeson at Peekskill in 1947 was orderly, peaceful and well received.

As we will see, it is perhaps too easy to blame everything that happened in 1949 on the local newspaper, the same paper that praised singer Robeson and his Peekskill concert of 1947. Paul Robeson was not a stranger to the Peekskill area. He was a favorite performer of both summer residents from New York City and "progressive" full-time residents, such as those at Mohegan Colony along Crompond Road. The Crompond Club of American Labor Party sponsored such a concert in 1946 with its usual mixture of music and politics. Sonny Terry and Brownie McGhee also offered their down-home folksy music that day. Donations amounting to $2,200 were contributed to the National Negro Congress. The local *Evening Star* reported:

> *An overflow crowd of some 3,000 people filled Mohegan Colony school grounds over Labor Day to hear Paul Robeson, noted Negro singer.*

Paul Robeson's summer concerts drew thousands to Peekskill and nearby locations in 1946 and 1947. There was no disorder, no screaming, no rock throwing, no personal violence, no riots, no national attention and no hard feelings. Meanwhile, world events and alliances were changing. Though it had been a wartime ally of the United States, the Soviet Union soon became a communistic enemy. Those who publicly favored the Russians in any way were labeled as "subversive."

The Soviet Union, under leader Joseph Stalin, demonstrated its ability to explode a nuclear weapon in 1949. Full-scale war with North Korean communists was just one year away. Julius and Ethel Rosenberg were convicted in 1951 on a charge of delivering nuclear bomb designs to the Soviet Union, and they were executed inside Sing Sing prison at Ossining.

Social and Political Background to 1949 Events

The violence and civil disorder that took place at Van Cortlandtville in that otherwise typical 1949 summer were international news events. The shock waves of that social earthquake were a magnitude of "ten" on the historical scale.

Communists, World War II military veterans, union members, socialists, patriots, racists, Jew haters, riotous teenagers, civil rights advocates, Ku Klux Klan members, free thinkers, musicians and combinations of all of these merged together in one place at one time with explosive results. Decades of seething racial prejudices, social resentments and political passions found their sudden expressive and explosive voice in

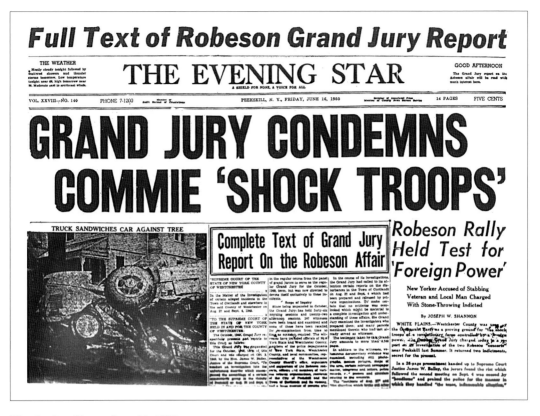

The *Star* headline on June 14, 1950.

a forum surrounding Paul Robeson's considerable popularity, unmistakable talent and apparent politics.

Paul Robeson, born in 1898, was an exceptional African American student, athlete, lawyer, entertainer and international celebrity. He shared a growing anxiety about the rigid social and economic status quo into which black people in America were locked during the early and mid-1900s.

While some blacks may have found success in certain areas, on the whole they were effectively excluded from participation in wider American lifestyles. Robeson knew that he was an exception due to his obvious natural talents that were recognized, admired and marketed by white folks. Yet as he succeeded within the white world, he began to see an America that few of his skin color saw. He was disturbed and frustrated by an unchallenged and growing racial inequality of opportunity, and he spoke of these things in public.

He stated:

> *I challenge the notion that success of a few Negroes, including myself or Jackie Robinson, can make up for $700 a year to thousands of Negro families in the South. That is the reason my own success has not meant what it should mean.*

Mr. Robeson was not alone in questioning America's values in those years, especially during the 1930s' serious economic difficulties.

The gritty reality in the novel *The Grapes of Wrath* by John Steinbeck shows devastated white farmers forced to leave their homes in some states. Henry Fonda's movie character Tom Joad expresses a general defiant frustration with American economic and political systems that seemed to favor the wealthy and powerful.

Socialism as a system of government that regulated economic equality was both openly and secretly attractive to many American intellectuals and others during the 1920s and '30s. Even communism's paper ideals seemed to value the "workers of the world" more than did men like Herbert Hoover, J.D. Rockefeller, Wall Street financiers and others of wealth and power. There was popular talk of revolution within this country in those years as a possible alternative for a better life.

As an intellectual, a bright black man who mixed in artistic and showbiz circles, Paul Robeson heard this disgruntled and idealistic talk, and he agreed that some of it applied to those whom he called "my people." Perhaps there were better alternative systems and practices in other countries. Robeson was curious and open-minded, so when he received an invitation to visit Moscow in 1949, he accepted and went. He was received in Moscow with tremendous enthusiasm.

Paul Robeson in Moscow: 1949

"In Russia, for the first time, I felt like a full human being. No color prejudice like in Mississippi, or in Washington [D.C.]." Paul Robeson stated these feelings to the House Un-American Activities Committee in June 1956. When asked why he didn't stay in the Soviet Union, he answered:

> *Because my father was a slave, and my people died to build this country. I am going to stay here and have a part of it just like you do.*

The committee asked Robeson, "While you were in Paris, did you tell an audience that the American Negro would never go to war against the Soviet government?"

Robeson replied, "May I say that is slightly out of context." He later continued:

> *I stand here struggling for the rights of my people to be full citizens of this country. And they are not. They are not in Mississippi. They are not in Montgomery, Alabama, and they are not in Washington. They are nowhere, and that is why I am here today. You want to shut up every Negro who has the courage to stand up for the rights of his people.*

Robeson did not excuse his acceptance of the Stalin Peace Prize in 1952 or his praise at that time for the Russian leader's "deep humanity." The gist of the matter was that, because Mr. Robeson would not swear that he was not a communist, his passport was revoked. This ruling was later overturned and his passport was restored in 1958. But

severe damage had already been done to his American reputation and income. The national attention the events at Van Cortlandtville received in 1949 led directly to the formation of the House Un-American Activities Committee that allowed the rise of Senator Joseph McCarthy, who abused his authority by turning investigation into persecution and paranoia.

World War II patriotism, sacrifice and hard work came and went. Racial issues remained unsolved because they were mostly ignored. Russian communists were no longer wartime allies, but were increasingly becoming America's enemy. An explosive mixture of politics and race was simmering.

A Paul Robeson outdoor summer concert and picnic were announced to take place in a Van Cortlandtville field in 1949. There and then, a long, bubbling, steaming bottle of rage, frustration, confusion and hatred blew up in a violent spectacle witnessed by the whole world.

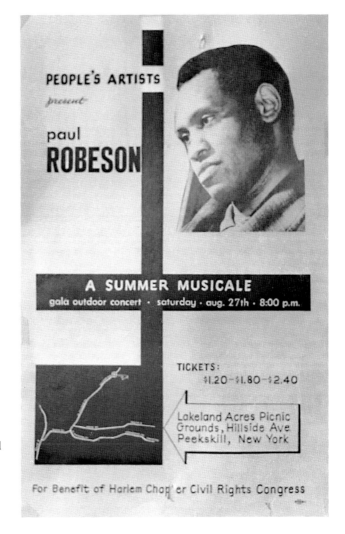

This original promotion poster featured Paul Robeson as the headliner for a "Summer Musicale, Outdoor Concert" to be held at Lakeland Acres picnic ground on Oregon Road in 1949.

The movie *Rashamon* (1950) by Japanese director Akira Kurosawa may apply to perceptions of the two 1949 Robeson concert events. The movie retells the story of a tragic incident in the woods that resulted in a deadly confrontation. The four survivors share their stories of what happened in great detail. Each narrative is totally believable, and totally unique.

Role of the *Peekskill Evening Star*

Peekskill's former daily newspaper, the *Evening Star*, played a strong role in the 1949 events. Regular daily news that summer detailed the increasing cases of polio paralyzing young children. There was a heat wave in August, with one day reaching a sweltering 98.5 degrees. A soapbox derby attracted five thousand spectators. The paper reported that 3.2 million bushels of wheat were being stored in the Hudson River ghost fleet ships, which were anchored downriver across from Peekskill.

The first mention of the Lakeland Acres concert was made on Tuesday, August 23, to take place on Saturday, August 28, 1949: "Robeson Concert Here Aids Subversive Unit." Apparently, the state attorney general labeled the two sponsoring organizations as subversive. A provocative letter to the editor was printed on Wednesday that week, stating, "I am not intimating violence, but I think we should give the matter serious consideration."

The newspaper editors made it clear that they were not tolerant of the People's Artists and the Civil Rights Congress who were sponsoring the concert. They considered these groups

> *dedicated not to the broader issue of civil liberties, but specifically to the defense of individual communists and the communist party.*

A front-page editorial spelled out the paper's position. The editorial endorsed forceful disagreement, but not violence. "Time was when the honor would have been ours" to have Paul Robeson sing nearby, but now the paper's editors suspected that his allegiances were captured by communists.

> *The time for tolerant silence that signifies approval is running out. Peekskill wants no rallies that support iron curtains, concentration camps, blockades, NKVDs.*

On August 27, area veterans groups that were almost entirely white called for an "orderly and peaceful" demonstration, as this would be "in contrast to the force and violence practiced in communistic and totalitarian countries."

A great question and interesting issue is how Peekskill's hundred-plus black World War II veterans felt about all of this.

Two Riot Events at Van Cortlandtville: 1949

An outdoor concert event for Paul Robeson and others was scheduled for August 27, 1949, at Lakeland Acres located off Oregon Road in Van Cortlandtville in the town of Cortlandt. The singing never happened and Paul Robeson never appeared. Instead, according to the August 29, 1949 *Evening Star*:

> *Fists, stones, boards and bottles were used in the melee. Two Westchester veterans were seriously injured, and six Robeson partisans reported to Peekskill Hospital for first aid. One person...remains in the hospital. A knife wound injured his liver, a doctor said.*

The next day, a navy veteran's father related that his son was standing in a line when he was grabbed around the waist and stabbed in his side by a Negro. The *Evening Star* reported on August 30 that "this was the thing that set off the riot because then his friends and others charged at the Negroes and others who were on the road." As for who did what to whom, and who started what first, these details become less important in the context of this three-hour extended riot, followed by another such event six days later.

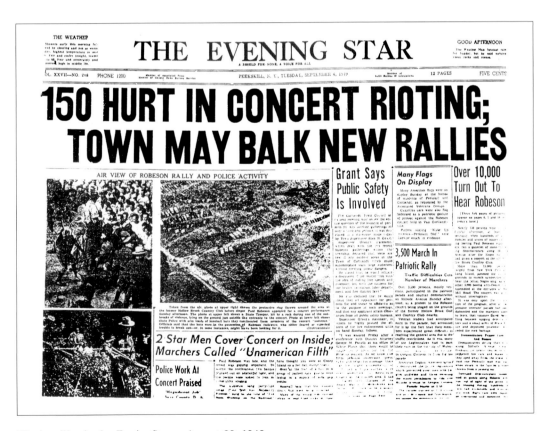

The headline in the *Evening Star* on August 29, 1949.

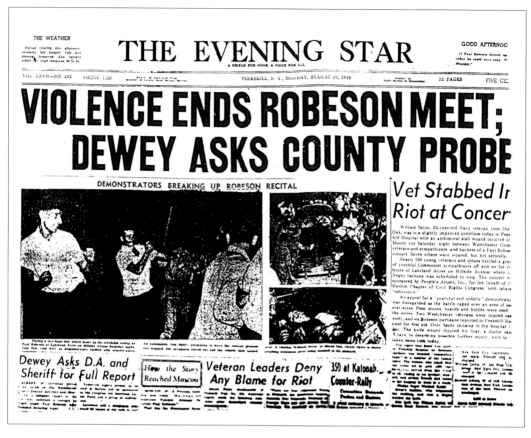

The *Evening Star* headline for September 6, 1949.

A second concert attempt was rescheduled for September 4, 1949, at the former Hollowbrook Country Club Property, an abandoned golf course about two miles north of Peekskill and one mile south of Putnam County.

Everyone knew that violence was possible, as fourteen Hudson Valley veterans' organizations indicated that they would be on the scene to protest the Harlem-based People's Artists event. The day before the concert, New York's Governor Dewey ordered all available state policemen to the scene to prevent disorder. Many Westchester County policemen were also on the scene.

About seventy-five buses and hundreds of cars carried concert audience members to the former golf course. The lead entertainer, Paul Robeson, arrived and made a fine concert before an estimated fifteen thousand people. Then:

> *Despite anti-riot precautions by 900 policemen, the angry demonstrators surged upon the 15,000 Robesonites when the concert broke up late in the afternoon. A barrage of stones and pop bottles was hurled. Cars were overturned, one was set afire, bus windows were broken and private automobiles damaged.*

This car was smashed and overturned after being attacked by rioters in Van Cortlandtville when the scheduled Robeson concert event spun out of control.

Thirty people were treated at Peekskill Hospital. One car that was stoned on Gallows Hill Road went out of control and hit a tree. Rioters overturned this car and seven others. According to a September 5, 1949 article in the *Chicago Daily Tribune*:

> *Two busloads of Negroes who had been visiting Franklin D. Roosevelt Memorial library at Hyde Park unwittingly drove into trouble…they also were stoned.*

This was out of control violence. It was chaos. These disgraceful events became national news. Yet anti-concert protesters proudly carried signs and banners reading: "Wake Up America, Peekskill Did." What did they mean by this?

"Wake Up America, Peekskill Did"

Both sides of this conflict wanted Americans to awake from indifference, to stand up with social actions in one way or another. Many people did suddenly wake from complacency and apathy, but not in the most helpful ways.

The Civil Rights Congress wanted more than anything for American decency to arise and deal with the outrageous racial injustices within this country. Its supporters described the rioters as fascists. World War II veteran organizations wanted people to be aware of the growing anti-American communistic movements inside the country. There were some real concerns and understandable paranoia about Russian communist motives in the world in those years. English leader Winston Churchill described an "iron curtain" falling over Europe due to Soviet control in 1946.

In the summer of 1949, otherwise quiet Van Cortlandtville became a dangerous laboratory for simmering, extreme attitudes. Anti-communist rioters, protestors and war veterans created national headlines when they taunted and then tangled with "communist sympathizers," especially when such perceived subversives were black skinned or Jewish. The burning of a twelve-foot-high "fiery cross" on a hill overlooking the Lakeland Acres concert site was a signal that the Klan was present and involved and was taking advantage of veterans' genuine patriotism to turn the scene into a public orgy of violence and hate.

The dozen or so Hudson Valley veterans' organizations that protested the concerts and provoked the violence clearly had Governor Dewey and the U.S. Congress on their side. Thus, they were glad to proclaim: "Wake Up America, Peekskill Did." By giving Peekskill this credit, the ownership of the events was brought to Peekskill, and ever since they have been largely identified, rightly or wrongly, as the "Peekskill Riots."

Reports, Committees and Then the 1960s

People took sides. The 1949 Van Cortlandtville events were included in a U.S. Senate and House of Representatives 1954 report that recommended outlawing the Communist Party in the United States. That report, and others, in the mid-1950s motivated the Congressional Un-American Activities Committee, whose activities were often described as a "witchhunt" against subversive "reds," communists, "communist sympathizers" and "fellow travelers" in the United States.

Several pro-concert and pro-Robeson writers in various publications immediately waged a written counteroffensive. Howard Fast wrote his impassioned, illustrated eyewitness booklet, *Peekskill, New York*. The American Civil Liberties Union issued a report titled "Violence in Peekskill." The *National Guardian* "progressive newspaper" published outraged firsthand accounts and candid photos of the violence. The Westchester Committee for Fair Inquiry into the Peekskill Violence printed a booklet with subheadlines such as "Native Fascists Triumphant as Authorities Fail to Prosecute." One report charged: "Super patriotism becomes mass violence, mass hate. Anti-Communism turns into anti-Semitism, anti-Negro."

Mr. Robeson commented, "Those Klan-inspired, police-condoned hoodlums cannot stop the song of freedom in America." Governor Thomas Dewey basically said that the riot victims got what they deserved:

These followers of red totalitarianism, which teaches violence and suppression of individual liberty, were themselves made the victims of lawlessness and suppression of fundamental rights.

So it went, "communists" and "fascists," and so it has gone ever since.

The sad part of this story is that those who advocated for racial equality and economic and social justice not only lost the immediate battle, but also suffered the casualty of the entire next decade. The 1950s saw near total indifference to these simmering issues. No progress happened in these areas until the civil rights movement of the 1960s.

Commemorations Fifty Years Later

Noted African American Paul Robeson was at the very center of profound American events, values and feelings that are still alive among us. For the fiftieth-year commemoration there was still some confusion and mixed feelings about recalling those particular events.

"A Remembrance and Reconciliation Ceremony" was held in the year 1999 to recall and analyze the dramatic events that occurred a half century earlier. Paul Robeson Jr. was present for the event held on September 4 at the former Hollowbrook Golf Course, the site of the second concert event and the scene of considerable violence. He was accompanied by leaders in politics, the NAACP and the ACLU.

Paul Robeson Jr. expressed that his father would be "thrilled that we will use the anniversary of Peekskill to express his abiding belief in peaceful relations among all people." Other celebrities present were Ossie Davis, Ruby Dee and Pete Seeger. County Executive Andrew Spano spoke of the need to tolerate all kinds of speech.

Paul Robeson, All-American was a biographical play staged by noted Westchester actor Ossie Davis and performed at the Paramount Center for the Arts. "Walking in Paul Robeson's Footsteps, The Upcoming Black Radical Congress: Setting a Black Liberation Agenda for the 21st Century" was held at the former One Station Plaza in 1998. The event featured outspoken advocates for African American political action.

Caleb Peterson: From Drum Hill School to Hollywood

Peekskill at one time had more direct Hollywood connections than actors Mel Gibson and Paul Reubens. That connection was Caleb Peterson, a singer featured in a dozen or so movies who worked with such notable celebrities as Lena Horne and Clark Gable.

Caleb Peterson began his career on the stage of Drum Hill School, where his gift with public speaking led him to join oratory contests at Peekskill High School. After winning the state oratory contest, he went on to take the National Oratorical Contest top prize in Oklahoma City. Peterson's singing career started at the Paramount Theater on Brown Street. His songs were accompanied by the theater organist Banks Kennedy

National civil rights leader James Meredith (left) was greeted by Mr. and Mrs. Caleb Peterson at their home in August 1966.

in the days before film when live entertainment pleased audiences and local talent had a chance to be seen.

An admirer of entertainer Paul Robeson, Caleb Peterson also sang "Old Man River" in the *Showboat* movie of 1951 as Mr. Robeson had done in the 1936 film. Peterson was even trained by the same voice coach. Just as Paul Robeson felt his singular success brought greater social responsibility, Caleb Peterson also felt he should campaign for more African American opportunities in Hollywood. He formed the Hollywood Race Relations Bureau and staged pickets at an Academy Awards program for more opportunities for black actors in movies.

Caleb Peterson was a childhood friend of Mr. Charles Bolden here in Peekskill. They attended college together in West Virginia and remained close friends for the rest of their lives.

Troubles and Transition

Neighborhoods

When the population numbers and percentages (less than 5 percent) of African American residents were quite small in comparison to white residents, there was no isolated ghetto or separate black neighborhood. Before 1900, blacks and whites lived where they could afford to live in a time when work and shopping were mostly within walking distance. As blacks became more affluent in the 1950s, a real estate housing discrimination became obvious here in Peekskill.

Peekskill was a working-class community of union workers, mechanics and factory and retail employees in 1915. An electric trolley system with thirteen miles of track was installed to bring workers into the village for five or ten cents. Peekskill-born William J. Lewis retired from his job as a yardman after twenty-eight years at Dain's Lumber Company in 1954. Stanley Peterson retired from employment at the Standard Coated wallpaper factory in Buchanan in 1960 after forty-five years on the job. Both were members of the Lone Star baseball team in the early 1900s, when they were youngsters.

A significant tribute during the 1950s was a large, bronze memorial plaque dedicated to James Hankins who worked for fifty years as chief cook at the former Peekskill Military Academy. The lettering below the PMA insignia states: "In appreciation of his many years of faithful service, 1900–1950."

African Americans from the Southern states moved closer to Northern factories and employment opportunities in New York State, including Peekskill. Eastern European immigrants arrived here in the 1890s, and immigrants from Italy arrived in the 1920s. Later, in the 1940s and '50s, blacks were attracted to employment in this area working on the Catskill Aqueduct system, at the Veterans Administration Hospital complex in Montrose, the General Motors assembly factory in Tarrytown, the Con Edison power plant in Buchanan and other places.

Mr. Leonard Carrington pointed out that blacks generally had a harder time getting good jobs in this area prior to and following World War II. There was resistance to hiring African Americans at the Fleischmann Plant, but a meeting between its executives and

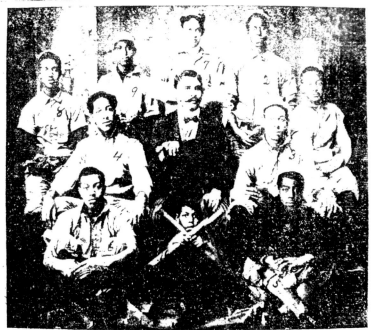

'Lone Stars' Active Here in 1902

**Old-Time Negro
Baseball Team
Rated Highly**

One of the greatest colored baseball teams ever to grace the diamond in Peekskill was that known as the "Lone Stars Baseball Club." The team competed with the best of the amateur and semi-pro clubs back at the turn of the century. All but two members of the original "Lone Stars" are living today, according to John Hutchinson, of South James Street, who was catcher on the team.

Incidentally, it was through Mr. Hutchinson that The Evening Star obtained the loan of a photograph of the "Lone Stars." This photograph, taken in 1902, is one of Mr. Hutchinson's prized possessions.

The "Lone Star" were one of the local clubs competing in a baseball league in Peekskill in 1902. Among the other teams were the "Teamsters," the Elks and the Peekskill Clerks.

Charlie Hicks, Jr., now operator of a taxicab service in Peekskill, was the mascot of the team. William Harris, sporting a derby hat and a cane, was manager.

The Lewis boys, Eddie and Willie, were members of the club. Ed, now a chef at one of the nearby inns, is shown at the extreme top left of

(Continued on Page Two)

Members of the "Lone Stars" baseball team which was active in Peekskill in 1902 were, front row, left to right: John Hutchinson, Charles Hicks, Jr., mascot; William "Cookie" Conway; middle row, left to right; Pearl Peterson, Manager William Harris, Stanley Peterson; top row, left to right: Eddie Lewis, William Powell, Fred Moshier, William Lewis and Captain Crawford. Others who were members of the team but who are not in the picture were Garfield Tallman, Frank Burton and John West.

The Lone Stars baseball club team of 1902 was featured in an undated *Evening Star* article. Listed were John Hutchinson, Charles Hicks, William Conway, Pearl Peterson, William Harris, Stanley Peterson, Eddie Lewis, William Powell, Fred Moshier, Garfield Tallman, Frank Burton, John West and Captain Crawford.

the local NAACP helped clear up the hiring issue. In response to these situations, many blacks went into business for themselves in fields such as taxi driving, tailoring, running restaurants and taverns, hair dressing and more.

The locations of distinctly African American churches are good indications of where black people lived. The AME Zion Church on Park Street was placed in an area convenient or attractive to its parishioners at a time when most people walked everywhere. Peekskill's African American residents have always lived among white residents on and along Main Street, Howard Street, Park Street and James Street. Others lived along Central Avenue, Diven Street, North Division Street and Crompond Road, either renting or owning houses and properties.

John Alaire is listed as a "colored" veterinary surgeon with an office on South Street and his residence on Diven Street in the late 1800s. Mr. Alaire's neighbors were the Hutchinson family. George and Louise Hutchinson later owned a bar and grill business on North Division Street and their residence was near Oakside School on John Street.

Lydia Hicks Hutchinson was part of the crowd when President Lincoln spoke from a baggage car at the old depot at the end of Central Avenue on Water Street in February 1861. The freight station, which is presently being rehabilitated into a museum, is located on the same site as the old depot.

During the 1930s, James Street was home to Thomas Tinsley, Waverly Carrington, Margaret Moshier, Arthur Fipps, Harry Tapley, Arthur Fauntleroy and Charles Hicks's billiards parlor. Park Street was a mixed neighborhood as well. George Jackson, Joseph Lipscomb and Alfred Puryear lived along Park Street between Charles Street and Armstrong Avenue. Howard Street was home to Hawley and Harriet Green in the 1830s, and the couple also owned properties on James and Main Streets. White families largely occupied Howard Street in the 1930s. Today it remains a quiet and tidy, mostly black and Hispanic neighborhood.

Neighborhoods after 1900 became more concentrated according to ethnic and racial identifications, but without severe separations. A revealing look at those days is offered in an interview that was printed in the former *Peekskill Herald* newspaper in 1992, titled "Growing Up On Park Street." Pauline Knizeski recalled her life there during the 1930s:

> *Living on Park Street back then were Polish, Irish, Italian and Jewish immigrants. Black families lived in the flats on the corner of Park and James Streets. We all played together and went to school together…Black families and white families, they were in our house and we were in theirs. We were all happy then and helped one another. Ours was a good old house with lots of love inside.*

The area to the south of Oakside School became a dominant black neighborhood after the urban renewal activities of the 1960s and '70s along John, Spring, Hadden, Belden and Decatur Streets. Now at the center of this neighborhood are Bohlmann Towers on Main Street, Lepore Park, Kiley Center and the Oakside School. One might suggest that Bohlmann Towers apartments is itself a vertical neighborhood, considering the number of people who live, raise families and know other people who live there.

Another traditional black neighborhood grew along Harrison Avenue and its side streets during and after the World War II years of the 1940s and '50s. These residents eventually built Mount Lebanon Baptist Church. The church hall took several years to complete and it was dedicated in 1968.

Leonard Carrington graduated Peekskill High School in 1944 and recalls being among very few African American students at that time. After high school, he was a navy machinist mate at a San Diego ship repair base. He mentioned that at his marriage ceremony in 1950, almost all the black people then living in Peekskill attended his wedding.

There was an unspoken, silent housing discrimination in Peekskill during the 1940s and '50s. Mr. Carrington makes it clear that realtors at that time directed black people only into some areas and neighborhoods. When he and his wife were looking to buy a house, they "were steered to certain sections" of the city after World War II.

Several generations of the Leonard Carrington family are seen here in 1973. The baby, Kelsy, is held by Carolyn Carrington. Leonard's wife, Gleanor, is seated beside her. Mr. Carrington's mother, Sallie, and his grandmother, Amie, were also present.

The area known as "The Boulevard" or "Mortgage Hill" was developed in the 1920s. It was an all-white neighborhood until Bill Amory built a house at the corner of Crompond Road.

Bohlmann Towers

In 1961, the Bohlmann Towers apartments were built on Main Street as low-income housing by New York State. Governor Nelson Rockefeller spoke at its dedication, praising it as "an outstanding example, with a public housing look." It appeared at first that Bohlmann Towers would be able to handle all of the people who had been displaced by the urban renewal agency, but by 1967 it was already filled up.

The Towers were at first occupied by many white families. But as the demolitions of entire downtown blocks continued in the late 1960s, the pressure for the relocation of Peekskill's black families became more intense. There was some tension and several incidents occurred between white and black families at the Towers in those years. After nearly fifty years of existence, Bohlmann Towers has become a mainly

African American neighborhood. It is a kind of vertical neighborhood, where children are born and grow up recognizing this apartment complex and the nearby streets as their home.

William Shands served as executive director of the Peekskill Housing Authority for eighteen years, from 1984 to 2003. Originally from Virginia, he worked as a financial analyst for General Foods in White Plains. He was also a sergeant in the air force and a dedicated member of Mount Olivet Baptist Church. He passed away in 2003.

An elegant bronze portrait statue of Mr. Shands stands in the plaza of Bohlmann Towers apartments at 807 Main Street. The William E. Shands memorial was made by artists Wilfredo Morel and John Payne. Mr. Morel also fashioned the intriguing industrial art piece *Fluid Mechanics* out of former molasses pipes standing at Charles Point Park.

The housing authority board was led by Gheevarghese Thankachan for many years and was supported by members Larry McKenzie, Amy Wiggins, Linda Edwards, the Honorable Melvin C. Bolden, Sandra Bond, Eric Hines and Lorraine Robinson.

Dunbar Heights apartments on Highland Avenue was completed in 1952, originally in response to the housing needs for returning World War II veterans. The first residents were mostly white. By the late 1960s, mostly black families lived at these public housing apartments. Dunbar Heights is composed of ninety-six apartments in thirteen buildings.

Urban Renewal Dislocations

Confusion, chaos, violence and destruction were a large part of the late 1960s and '70s, and I have chronicled this in my book, *Old Peekskill's Destruction*. Peekskill's black community was at first confused, then became alarmed and finally yielded to the complexity and scope of the federal state and local efforts to transform an old industrial village into a modern metropolis.

A residential area became the first urban renewal target zone: Academy Street. It was a peacefully mixed area for those of Italian, Polish, English and African descent. A report indicated that a third of these residents were "black, and half of them qualifying for public housing." While white families may have had relatives or alternative housing in other places, most of the black families did not have such options.

Suspicions and accusations arose during the 1960s that the so-called urban renewal program of destruction and construction at the same locations had become "Negro removal." The Peekskill Council approved the Academy Street Urban Renewal Project in January 1961. It became the first community in New York State to receive grant money under that program.

It was reported that 141 families, 25 businesses and 39 individuals were displaced within this one area. More than four mostly residential blocks with about 250 structures were leveled by 1968. About 500 people were directly affected, and 189 relocation claims were paid. The mostly black church, the Christian Missionary Alliance, known

Pictured inside the Studio for Beauty by Madeline after its relocation to South Division Street in 1970 are, left to right, Madeline Carey, Mrs. Juanita Jackson and Mrs. Bessie Jefferson. The seated customer was Mrs. Helen Oglesby.

as "Lily Pond" on Broad Street, was torn down. This neighborhood church can be traced back to the 1930s as the Wesleyan Methodist Church and the 1940s as the Gospel Tabernacle of the Christian Missionary Alliance.

The properties generally became the Crossroads apartment and shopping complex between Main and South Division Streets, from Broad Street to James Street and beyond. Crossroads Apartments off Brown Street appeared in the early 1970s. A new A&P supermarket (where Rite Aid is now located) and a McDonald's restaurant along Main Street were among the first commercial tenants in the new Crossroads shopping area.

The Charitable Six

The Charitable Six was an association of six African American men who worked to donate money to various charitable causes in Peekskill. Organized in 1961, it sponsored fundraising events that had social value. Its members in 1968 were Odell Jackson, David Whitefield Jr., Benjamin Hull, J.L. Hull, Coleman Smith Jr. and Leroy Hankins. This exceptional group donated money to the ambulance corps, hospital, NAACP, the Mount Lebanon, Mount Olivet and AME Churches, Little League and the Community Action program. They also organized special Christmas parties for children.

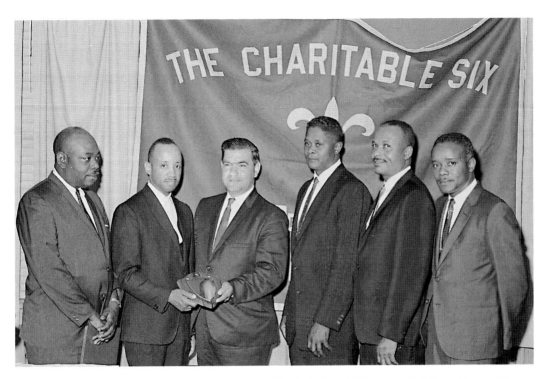

Peekskill's Catholic war veterans honored the Charitable Six in June 1968. Pictured, left to right, are David Whitfield Jr., Coleman Smith, Dr. Joseph Fontana, Benjamin Hull, Odell Jackson and J.L. Hull. Leroy Hankins was not available for this photograph.

The amazing success of these Charitable Six was entirely due to their goodwill and hard work, as none of the members was personally wealthy. Coleman Smith was employed as a Peekskill High School janitor and worked there with George McCrae. The members did not seek personal publicity. The volunteer efforts of the Charitable Six through many years reveal that the goodwill and positive actions by exceptional individuals make Peekskill's story exceptional as well.

Vietnam War

While everyone else was busy with their daily lives, dealing with civil rights and the changing national scene, a major military enterprise persisted in far-off Vietnam from 1964 to 1975. Required military service, or a "draft," was then in place. Many young men joined or were required to serve in Vietnam. Many thousands suffered wounds, and fifty-eight thousand Americans died during those years in Vietnam.

Chester John Moshier Jr. died in Vietnam while serving as a marine staff sergeant. He was killed during an enemy rocket attack upon his unit in 1968. His family then lived at Dunbar Heights. Sergeant Moshier graduated Peekskill High School in 1953 and served fourteen years in the U.S. Marine Corps.

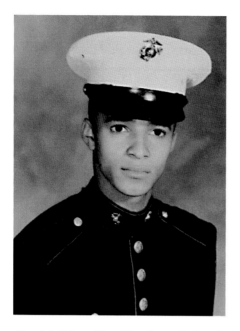 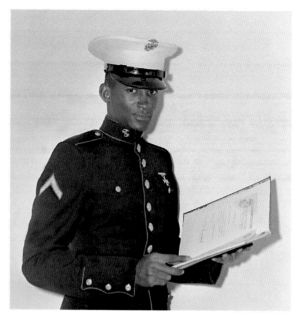

Above left: Private First Class James E. Overby Jr. won the Navy "V" Award for combat in July 1970, after serving as a marine in the Vietnam War.

Above right: Marine Private First Class Kurt Bentley received an award as an outstanding member of his unit in 1965.

James E. Overby of Peekskill experienced eighteen months of distinguished military service during the Vietnam War, serving in combat with a marine engineer battalion operating heavy equipment. He was later employed as a lineman for New York Telephone Company. He is now a supervisor with the Verizon Company. His father, James Elijah Overby, was a World War II soldier and was injured during the D-Day invasion of Europe in 1944.

Change, Rage and Opportunities

An outburst of vandalism took place in the summer of 1967 and caught everyone's attention. The result was forty-four large downtown storefront windows broken. Reverend Calvin Marshall, then pastor at AME Zion Church, responded with a letter to the *Evening Star* newspaper. Reverend Marshall wrote:

> *On the evening of July 27th an eruption took place in our community by a group of 200 black youth who sought to vent their frustrations not necessarily upon Peekskill, but against what they term the dehumanizing system they have been forced to live in through the course of their young lives…Their grievances are real. They deplore the living conditions, [and] urban renewal program that one youth termed not urban renewal, but Negro removal.*

Above left: Reverend Calvin Marshall greeted Franklin D. Roosevelt Jr. at AME Zion Church in 1966. Roosevelt was then a candidate for governor.

Above right: Charles Green stood in front of his tailor shop on Nelson Avenue after it experienced a fire in September 1968.

Six local churches agreed in March 1968 to advocate for a hundred units of "tax free" or low cost housing within the urban renewal area. Then came the incident in October that year at Frenchy's Bar when the white tavern owner shot and killed a young black man.

Reverend Franklin Wiggins was then head of the Community Action program. Reverend Marshall and Charles Saunders of the Black Unity Party publicly questioned and expressed concern about the number of people being displaced by government programs and the number of homes being demolished. Black people realized that they had little control and little say in what was happening at city hall. When the official response was unsatisfactory, a desire for a "Negro councilman" was expressed.

There was no African American representation at that time, and a seat on the council was available. Public comment again connected the "ineffectiveness of the urban renewal program" and the "discontent within the black community." The local NAACP, the Interfaith Council and various civil rights groups held a rally and demanded that an African American be selected to fill the vacant council position when Mr. DiBart replaced Mayor William Murden, who had resigned. These efforts were unsuccessful.

While at first blacks were somewhat intimidated and left out of urban renewal planning and activities, it appears that attitudes changed by 1972. A letter to the *Evening Star* in August that year boasted the headline: "NAACP Favors Area U.D.C.

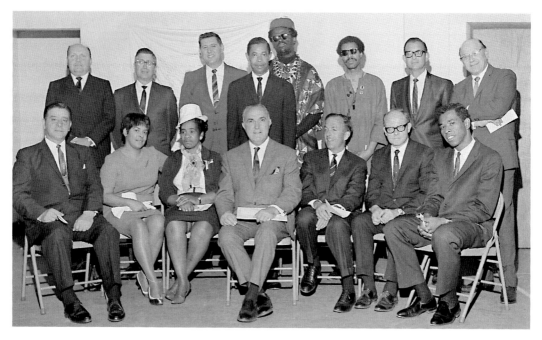

In response to some of the civic disturbances in the downtown, a panel for community dialogue met at Mt. Olivet Baptist Church in 1968. Pictured from the left, seated, are Police Chief Albert Vitolo, Mrs. Arlene Tapley, Mrs. Cleopatra Jones, Benjamin Hersh, Congressman Richard Ottinger, Francis Lough and Offie Wortham. Standing are William Benning, Edward Gibbs, George Risko, Sinclair Bynum, Bashir Aghase, Sahni Malik, Melvin Smith and Martin Nissenblatt.

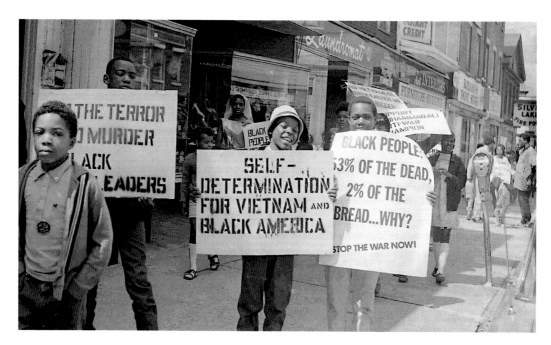

A demonstration protested involvement in the Vietnam War in May 1968. The Black Unity Party proceeded from its headquarters on Nelson Avenue to the draft board on Bank Street. At left is Edward Hollman, standing with a sign is Larry Roper, the woman near the storefront is Anita Smith and to the right is Lyn Bolton.

Reverend Franklin Wiggins (left) with Haywood Burns, Frank Scott and Melvin Tapley in a dinner at Mount Olivet Church celebrating the NAACP in 1962.

[Urban Development Corporation]." The writer spoke of the need for housing Vietnam veterans and the elderly: "We defy any politician who either seeks to destroy or delay U.D.C. housing plans." In 1976, the Peekskill Area NAACP gave David Ornstein an award. Ornstein was a driving force for urban renewal here. He was "recognized for his work to improve housing conditions in the city, and his various renewal efforts."

If there was a deliberate or unspoken intent to remove Peekskill's people of African descent during urban renewal, it certainly did not succeed. In the years between 1960 and 1970, the overall African American population percentages increased from 12 percent to 18 percent of the total community of 18,881 people.

Dr. Martin Luther King Jr.

Amid the local and national turmoil and trauma of the 1960s and '70s, one of the worst of all possible events occurred. On April 4, 1968, the Reverend Dr. Martin Luther King Jr. was assassinated. The death of Dr. King was a tipping point in so many ways; it was the beginning of a new era in race relations that has continued ever since.

The civil rights movement was sparked in Southern states by outrageous acts of racial segregation and defiance of racial harmony. Confrontations and incidents took place on buses, in schools, at voting booths or at ordinary lunch counters. These events were visible to everyone on television screens for the first time.

When mild and peaceful attempts were made to assert essential human rights, the responses usually involved violence by ruling white authorities. The use of attack dogs, fire hoses and police nightsticks to subdue demonstrators shocked a majority of Americans, who had never seen such situations or actions before.

Dr. Martin Luther King Jr. was an educated, eloquent, progressive and morally sincere Baptist minister in the city of Montgomery, Alabama. He first received national attention in 1955 with a boycott of buses in response to a lone woman's wish to ride a public bus in the seat of her choice. That mistreated, assertive woman was Rosa Parks.

As head of the Southern Christian Leadership Conference, Dr. King advocated nonviolence as a strong, positive force in society, enabling common people to assert their rights of full citizenship. This Southern American minister waged a moral war against prejudice, ignorance, violence and hatred that lingered from the bitter days of the distant past.

Noted for his poetic phrasing and eloquent delivery, Dr. King explained:

> *Returning violence for violence multiplies violence, adding deeper darkness to a night already devoid of stars. Hate cannot drive out hate. Only love can do that.*

He deliberately modeled his movement for social change on Mahatma Gandhi's activities in India. That one small, humble Indian man transformed that country by challenging and reshaping the British Empire. Dr. King would also transform the United States and defy its dominant bigots by asserting peaceful persuasion and resolute public demonstrations for rights presumably owned by all Americans.

Awarded the Noble Peace Prize in 1964, Dr. King spoke to the Swedish audience:

> *I accept this award today with an abiding faith in America, and an audacious faith in the future of mankind. I refuse to accept despair as the final response to the ambiguities of history.*

Perhaps the personal comparison with Gandhi was too accurate, as both national leaders were murdered by assassins. The deaths of both of these martyrs provoked widespread violence as an explosion of grief and outrage.

There was no turning back the tide of social change after April 4, 1968. National political leaders were motivated as never before to put Dr. King's reforms into new laws.

The Peekskill NAACP and VA Hospital committee for equal opportunity met in 1967. Pictured, left to right, are Mrs. Anna Mae Roberts, Dr. Leon Rackow, Dr. Mary Harper, Antonio Hernandez, Robert Turner, Mrs. Cleopatra Jones, Mrs. Arlene Tapley, Thomas Trainor, Leonard Green and Mrs. Robert Robinson Sr.

Almost every community took a new and deeply realistic view of themselves and the issues of race and economic opportunities.

Peekskill NAACP and Civil Rights Activities

The shock waves from Dr. King's assassination were felt in Peekskill on the night of April 4, 1968. Many people gathered in local churches to sing and pray. Some people felt a need to respond to violence with violence. There was talk of "blowing up Beach Shopping Center," and other such acts. Mrs. Mary Harper, Al Gaines and his first wife Leola Gaines McCoy used all of their persuasive abilities in talking to young people and visiting taverns to explain that violence would be self-destructive.

A sudden secret meeting took place in the basement of a local black businessman. Weapons appeared and threats were expressed to "burn down the town." As former president of the local NAACP Youth Council, Dr. Offie Wortham worked as a mediator in challenging this group to come up with a better plan. He was aware that the local police chief had contacted the state police and they were physically preparing to confront any riotous activities that night. He advised the group to be rational.

Dr. Wortham in turn challenged city officials to meet with those who felt impassioned toward destructive behaviors. The mayor and common council met in city hall that night with members of a delegation of residents, including Reverend Marshall. Inside city hall there was blunt talk. Some challenges and agreements were made. The need

EVENING STAR

A VOICE FOR ALL, A SHIELD FOR NONE

Today's Chuckle

Never buy anything with a handle on it. It means work.

PEEKSKILL, N. Y., MONDAY, APRIL 8, 1968 — Member of The Associated Press County News Bureau Service — 2 SECTIONS—26 PAGES TEN CENTS

2,500 IN TRIBUTE TO DR. KING HERE

By COLIN NAYLOR

The words of Dr. Martin Luther King, played on a tape recorder, vibrated through the large drill room at the Peekskill Armory yesterday afternoon as about 2,500 listeners were urged to practice the spirit of brotherhood the slain civil rights leader had preached.

The memorial service, lasting nearly two hours, held under the sponsorship of the Peekskill branch of the NAACP, attracted many more than participated in the march. In the audience were seminarians from Loyola Seminary at Shrub Oak, nuns, clergymen of various faiths, public officials, and members of local and area Catholic and Protestant churches.

The attendance at the Armory and the estimated 2,000 who marched through the business district was reported as exceeding the expectations of the sponsors. About half of the audience stood throughout the lengthy program, due to a lack of chairs which were hastily collected from all possible sources in the morning and early afternoon.

Better Relationships

Hopes for better relationships between white people and Negroes were expressed by Mrs. Arline Tapley, president of the local NAACP, Seymour R. Levine, chairman of the Peekskill Human Relations Commission, City Mayor William J. Murden, the Rev. Calvin C. Marshall who related talks he had had with Dr. King, and Rabbi Michael Robinson of Temple Israel in Croton, who had joined Dr. King on some of the marches in the South.

"We're proud of ourselves today," the Rev. Mr. Marshall said in a 10-minute talk which was loudly applauded. "But, he continued, "I wonder how many of us have the right to be mourning the death of Dr. King.

Faith Wavering

"I don't have the faith in America he had," Rev. Marshall declared, stating that Dr. King had told him once, 'you don't have any faith, Cal.'" The remark from Dr. King came, Rev. Marshall said, after he had warned the non-violence leader that peaceful demonstrations and the singing of "We Shall Overcome" no longer appeased younger militants in the civil rights movement.

Memphis, where Dr. King was shot, was not on the agenda of the civil rights leader at the time of the recent talk, Rev.

(Continued on Page Two)

A Peekskill newspaper headline for April 8, 1968.

for a Black Power center was recognized and supported. Outside the city hall steps, Dr. Wortham kept calm and held together a crowd of about a hundred people for nearly an hour as they waited for word on the talks inside.

The crowd vented its anger and frustration by singing many civil rights songs such as "Hold the Line" and "We Shall Overcome." The evening ended with a peaceful march through Peekskill from city hall to the AME Zion Church on Park Street. There was no violence in Peekskill that night, in contrast to the widespread violence in hundreds of areas nationwide. America was in a state of severe crisis with Dr. King's shocking homicide.

We were at a turning point. The root causes of racial tension and conflict at every level of American society had to be faced. Our most immediate feelings were expressions of sorrow and grief, confusion and anger, frustration and fury, with serious questions about our futures. We needed to walk and gather together. We needed to express our shared humanity and to believe that a brighter future was possible.

Peekskill's NAACP sponsored a solemn memorial public procession that started at the AME Zion Church, passed through downtown and ended at the state armory

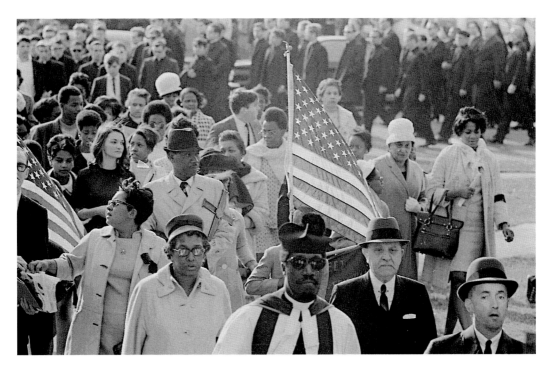

Some of the two thousand marchers in a procession to the state armory building on April 7, 1968, to commemorate the legacy of Dr. Martin Luther King Jr. Reverend Marshall, Mayor Murden and Judge Seymour Levine are pictured at center. To the left are Mrs. Arlene Tapley, Willie Mae Claytor, Mrs. Frances Honson and Belinda Saunders. To the right of the U.S. flag are Mrs. Jessie Bolden and Mrs. Estelle Bentley.

building on Washington Street. Organized and led by Reverend Marshall, about two thousand people participated in that somber and respectful procession. Local and area church people, public officials and citizens marched down streets and sidewalks led by a Christian cross and an American flag as unifying symbols.

Another five hundred people already were waiting inside the large Armory hall. NAACP President Arlene Tapley spoke briefly about the needs and hopes for the meeting to affirm better understandings between black and white Americans. Reverend Calvin Marshall recalled his personal comments to Dr. King about not having as much faith in America and his concern that the country's profound problems would not all be resolved peacefully or by good intentions.

The AME minister had his doubts about the national goodwill toward African Americans: "Dr. King may have become the last nonviolent Negro. It's a new ball game unless people deal honestly with each other." The Peekskill newspaper photographs of April 8, 1968 communicate the serious, determined and unifying local reaction to Dr. King's death. Reverend Marshall was pastor of a Brooklyn church in 1970, served as chairman of the Black Economic Development Conference and was an advocate for financial reparations from slavery days.

Leola Gaines McCoy is a Peekskill resident who was very much involved on the front lines of the struggles and trauma of those years. Her uncle became the first locally

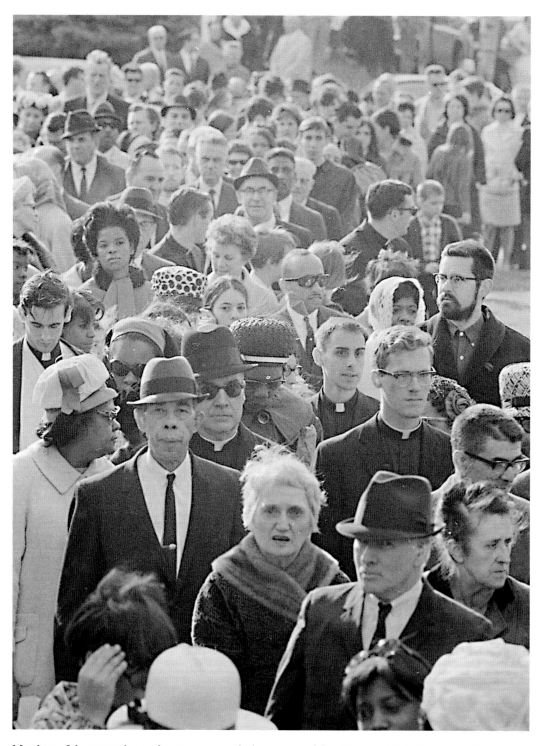

Members of the procession to the state armory during a mournful and tense crisis in America as they expressed the sadness and resolve of a wounded nation.

elected black official in her hometown of Selma, Alabama, with the help of Dr. King. She attended the 1968 March on Washington as a reporter for the *Putnam Courier*, and once spoke with Dr. King on the telephone. She also attended the solemn funeral in Atlanta for the assassinated civil rights leader, an event that prompted an article, "Our last Walk with Dr. King." Ms. McCoy was married to Albert Gaines, the World War II veteran and IBM engineer.

Peekskill Chapter of the NAACP

No other single organization has been as focused, effective and enduring in representing African American interests as the National Association for the Advancement of Colored People. The Peekskill Chapter of the NAACP was the first branch of the national organization to be established in Westchester County in 1937. Organized at the AME Zion Church, the group at first met in different Peekskill church meeting rooms.

Joseph Barnes was the first chapter president, and Kathleen Moshier became its secretary at only seventeen years of age. Kay stayed on as secretary for the next twenty years. She relates that in those early days there was some discussion about what "colored" meant in the organization name.

This community's most interesting and involved people have been active with the local NAACP organization. These individuals are mentioned throughout this book, as

Mrs. Kathleen Moshier expanded her home decorating shop in 1952.

Past president of local NAACP Melvin Tapley received a recognition plaque at a testimonial dinner in 1967. Pictured from left to right are Mrs. Anna Mae Roberts, Mrs. Olive Campbell, Mr. Tapley and Mrs. Arlene Tapley.

each era brings forth those who understand and respond to the contemporary situations as they arise.

NAACP leadership appeals to the wider community in its efforts to protect and advance its core values. Melvin S. Tapley was a guiding influence in the formation of the Peekskill chapter and was active as its president from 1952 to 1968. Mr. Tapley is featured in a book of individual biographies, *Who's Who In Peekskill*, written by Chester Smith.

The Peekskill NAACP Youth Council, under the leadership of Offie Wortham and Henry Tolliver from 1953 to 1957, became the largest in the United States with over four hundred members, most of whom were white. Talent shows were held at the former Masonic Temple on Brown Street and drew hundreds of young people and adults from as far as New York City. Minnie Jean Brown of the "Little Rock Nine" made her singing debut at one of these talent shows. Wortham and Tolliver equipped the temple with stereophonic sound before it was available to the general public.

Some years later, Byron Peterson, as president of the adult branch, embraced the public demands for assertive civil rights activities in Peekskill during the 1960s. Anna

Gary Fountain and Jerry Patterson tended flowers that were blooming in downtown planters in August 1969 as part of the Peekskill Neighborhood Youth Corps.

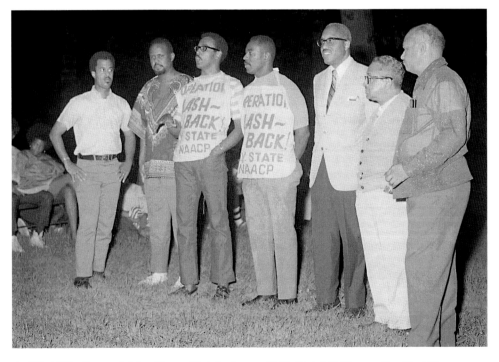

An NAACP rally was held at Depew Park in August 1969. Peekskill Chapter President Byron Peterson is pictured at left. Donald R. Lee was the state NAACP president and rally speaker.

Byron D. Peterson was elected president of the Peekskill Chapter of the NAACP in March 1969.

Mae Dickerson served as president in the 1960s. Mrs. Cleopatra Jones was one of the first advisors to the NAACP Youth Council and later became the adult branch organization president for several years in the 1970s and '80s.

Ms. Maude Belle and Peter Marshall were presidents through the 1980s. Marvin Church served as president in the early 1990s, while working as a banker with the

Bank of New York. Cynthia Roman once fulfilled the role as the top officer. Mrs. Vera McCorvey was president from 1988 to 1996.

Robert Spencer has been president of the Peekskill Chapter NAACP since 1996. He works at the Montrose hospital as a laboratory technician. Mr. Donald Duran, who has been a member of the executive board since 1960, is a longtime vice-president who knew Martin Luther King personally while working with the Southern Christian Leadership Conference. He rode the famous "Freedom Bus," which announced a new era in American civil rights, participated in "sit-ins" at racially segregated lunch counters and picketed companies for fair employment.

Peekskill NAACP has recently worked on voter registration drives, fair housing rules in home purchasing, representation on the board of education and teacher faculties and sponsors various useful activities for young people. Its most recent effort was to raise money for victims of Hurricane Katrina in the Gulf Coast region. The NAACP offers scholarships to area high schools, runs a youth program and maintains alertness to equal educational and economic opportunities.

The Peekskill Area NAACP held its seventy-first annual community service awards dinner banquet at Colonial Terrace in 2007. Receiving Community Service Awards were City Councilman Donald Bennett, School Board Vice-President Michael Simpkins, *Westchester County Press* Publisher M. Paul Redd Sr., Coleman Smith Jr. and Kathleen Chilocott. Featured as Tomorrow's Leaders were Cynthia Iyekegve and Porche Peterson. *Westchester County Press* was begun by Reverend Alger Adam of Hastings, New York, in 1928 to provide a forum and focus on African American people and issues.

Event organizers were Don Duren, Alberta Willis, Mrs. Ida Wiggins and Janice Whitman.

Soul Music, Soul Food and "Black Power"

African American soul music and its composers, singers and stylists charged through American culture like a hundred-foot-wide locomotive from the mid-1960s through the 1970s and beyond. When Ray Charles's voice played on radios and record players, a new intensity and depth of feeling was heard and appreciated in the land. Insight and passion by Aretha Franklin and others added to the chorus.

Ottis Redding's "(Sittin' On) the Dock of the Bay" was a somber theme song for those difficult years. Marvin Gaye's distinctive lyrics made one pay attention. When The Supremes and The Temptations teamed up and let loose in spirited song, it seemed like a kind of musical heaven on Earth. Popular music replaced the jazz age as Quincy Jones, Lou Rawls and others carried upbeat and romantic music through the 1980s.

Soul food is essentially hearty, tasty American food with an extra zing. Southern in style, some distinctive dishes such as okra-based gumbo and jambalaya share African, Indian and European ingredients.

On the political scene, it was Black Power. Largely denied participation and representation in the election process, Black Power asserted its right to be heard and its

issues dealt with. A local Black Unity Party advocated for political representation and attention to social and educational needs in the 1960s.

The "Afro" or natural hairstyle was popular, as an assertion of one's African identity through appearance was a hip thing to do during this era. There was more use of traditional African regional patterns in shirts and caps. Inventive language often combined with strongly rhythmic music led eventually into rap, hip-hop and other contemporary forms. Music and dance that was vigorous, innovative and personally expressive could be found on street corners and in concert halls. Vocal and instrumental music with a warm, shared spirituality was alive and well inside Baptist churches.

Comedians Dick Gregory, Richard Pryor and Redd Foxx created entertainment platforms that everyone could understand and appreciate even before Bill Cosby hit the big time. Richard Wright and Leroy Jones were popular authors in the literary field. Alex Haley's book *Roots* in the 1970s set a literary trend that connected history with the present and sparked an interest in exploring family histories to a degree never seen before.

Peekskill's Black Panthers

The local Black Panther Party grew from the Black Unity Party in the late 1960s. While one branch of Peekskill's Black Unity Party spoke and demonstrated for political representation and attention to African American issues, another branch worked to "culturally enrich Black people." One event was the musical play *Tell It Like It Is*, which dramatized the lives of an economically poor black family.

Produced and sponsored by Peekskill's Afro-American Sisters, the theater work was performed at Peekskill High School and Loyola Seminary. Mrs. Sarah Saunders wrote the piece as president of Afro-American Mothers of Peekskill. This organization had twenty-two active members in the late 1960s, including Mrs. Nellie Williams, Mrs. Sally Dolman and Mrs. Lillian Smith. Mrs. Smith supervised the younger girls ages twelve to eighteen. They performed in African clothing they had made themselves. The group also supported people in desperate need and helped them receive food stamps.

The Panthers were an association of individuals who were focused and forceful in their assertion of African American rights in this society. Several local people, including Charles Saunders, Belinda Saunders and Sandra Dolman, were active with the Panthers in the 1960s and '70s. The group advocated for more political representation, black teachers and educational material that dealt with their own distinctive history.

The Panthers said that if black Americans were not given or allowed respect and equal opportunities, these human rights should be taken by "any means necessary." A Black Panther Party storefront office was located on Nelson Avenue in 1969 and 1970, and it had about seventy-five local members.

Intent at their work, the drama workshop members of the Black Arts Festival in 1972 plan their activities.

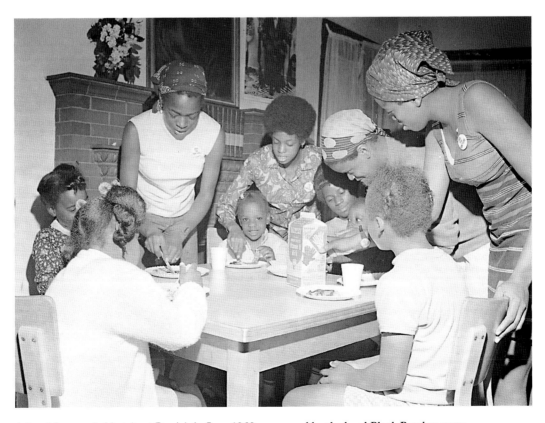

A breakfast was held at Aunt Bessie's in June 1969, sponsored by the local Black Panther party.

Churches

Peekskill's predominately African American churches are distinctive in their passionate Christianity as expressed, encouraged and led by sincere, eloquent pastors. The blending of music with message and the gradual movement toward a spiritual truth that anyone can understand is an experience that everyone should encounter.

Traditional Negro spiritual songs are an American creation that embody the living past and bring it into the present. Harmonized cadences combined with symbolic lyrics promote a shared experience that allows and encourages personal and religious renewal. Black churches are life preservers for enduring life's difficulties. These organizations are grand cruise ships that refresh their passengers while carrying them to a new and better destination.

Each pastor, minister and church official is deeply serious about his role and mission in the Baptist, Methodist Pentecostal and Church of Christ services. Baptist ministers make the teachings of Jesus approachable. They explain in a careful crescendo of religious truths that life is precious and best shared with others in the context of the greater glories that Christianity offers.

The AME Zion Church, Mount Olivet Baptist Church, Mount Lebanon Baptist Church, Refuge Church of Christ, Church of the Comforter, Christ Community Church and others here in Peekskill offer fellowship and spiritual guidance for those who wish to share the values that represent humankind's better nature.

It was not an accident that the most powerful, effective and lasting forces for change and renewal within American society in the 1900s were generated from the leadership, traditions, appeal and convincing messages of African American church congregations.

AME Zion Church

In addition to previous information mentioned in this book, there is more history to relate about Peekskill's African Methodist Episcopal Zion church. It is interesting to note the African American church activity in Peekskill before the AME Zion Church appeared on Park Street. An article printed in the *Westchester & Putnam Republican* newspaper on September 26, 1843, announced:

> *DEDICATION. The First Colored Methodist Protestant, named Macedonia, will be dedicated on Sunday the 8th day of October at 10 o'clock a.m....Sermon by S.K. Witsel, after which an address will be delivered by William E. Blakeney to the people of Color, on which occasion a public collection taken on the Church service to liquidate the debt on the Church. [signed] London W. Turrin, Supt., Peekskill, Sept. 26th, 1843.*

No street name is mentioned to locate this church. It is interesting to speculate whether this church group of 1843 or these named people of the "First Colored

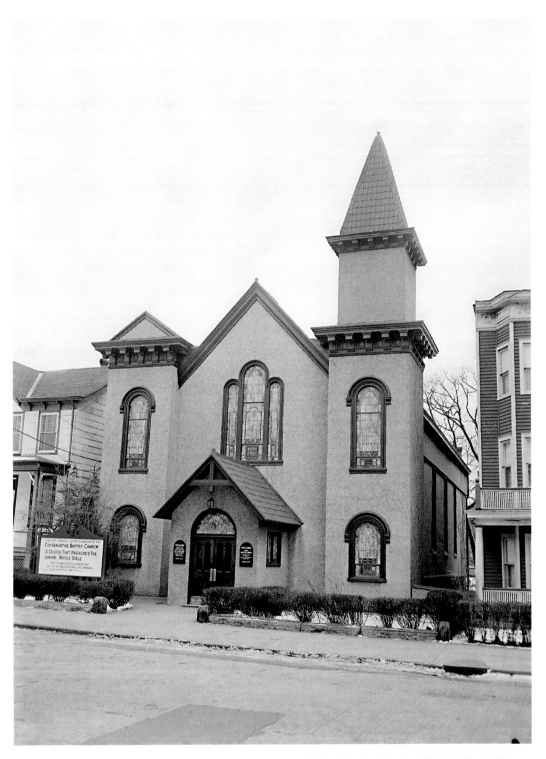

The Refuge Church of Christ on Main Street was the original First Baptist Church of Peekskill, which is now located on Highland Avenue.

Methodist Protestant" church were later active in forming the local African Methodist Episcopal Zion Church now on Park Street.

There are now two church buildings in use side by side on Park Street. The AME congregation has acquired the former St. Peter and Paul's Orthodox Church building. The Church of the Comforter now occupies the previous site of the AME Zion Church of Peekskill on Park Street.

The AME Zion Church pastor in 1875 was George Smith, who lived nearby on Park Street. Dr. Stephen Conrad (doctor of divinity) of the AME Zion Church was the first African American minister to head the seven-member Peekskill Pastor's Association in late 1930s. His father was a one-time slave who fought with the Union army and fathered a family of eleven children. Stephen Conrad attended Howard University and served two years in the U.S. Navy. The church's pastor in 1943 was Reverend Joseph D. Virgil, who served for only five months. Park Street AME Church hosted meetings for the local branch of the NAACP for many years.

The current pastor is the learned Reverend Lee A. Thompson Sr., and Mr. Doug Smith is a masterful musical accompanist. Outside the present church is a clever sign asking: "What's Missing Between CH…CH?" (Answer: "UR.")

Mount Lebanon Baptist Church

Mount Lebanon Baptist Church at 648 Harrison Avenue began with meetings in a Lower South Street home in 1952. Congregations later met in the downtown Riley Building. Land for a new church building was bought on Harrison Avenue in 1954. Work on the church foundation began in 1956 and 1957. Reverend Richard Puryear was the driving force behind the building plan. He helped raise the money and supervised the construction.

A memorial plaque mentions Reverend Ernest E. Drake as pastor in 1968, with J.L. Hill as chairman of trustees and William R. West as chairman of the deacons at that time. Reverend Floyd Warren helped develop several church activities as assistant pastor.

In 2005, the Peekskill City Council recognized the retiring Reverend Mervyn David for his thirty years of service as pastor at Mount Lebanon. Reverend David helped establish the ongoing Food Pantry, the Youth Recognition Team and a scholarship fund. Reverend David has been chaplain for the Peekskill Police Department for several years.

Reverend Catherine Brooks, associate pastor at Mount Lebanon, received the Distinguished Citizen of the Year award in 1989 for her work with the Moment of Truth Choir broadcasts on local radio station WLNA on Sunday mornings. She was also recognized for keeping Lepore Park free of unwanted activities and sponsoring the Emmanuel House youth program.

The Paul Robeson Foundation sponsored a program at the former Hollowbrook Golf Course for the fiftieth anniversary of Mr. Robeson's concert and the related disturbances that took place there in 1949. A reception was held afterward at Mount Lebanon Church.

Right: Ernest Murphy (on the scaffold) and John Love (below) worked on the foundation of Mount Lebanon Baptist Church on Harrison Avenue in 1955.

Below: Mount Lebanon Baptist Church sponsored a debutante cotillion at Colonial Terrace in November 1969. Miss Princeene Drake was cotillion queen.

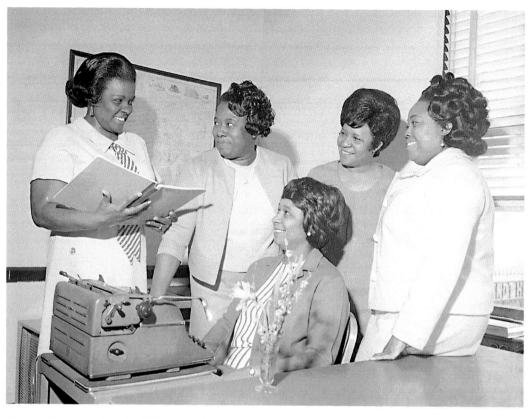

The cotillion committee for 1970 included Mrs. Althea Mahaffey, Mrs. Ernest Drake, Mrs. David Whitfield and Mrs. Floyd Warren. Seated is Mrs. Leroy Hankins.

Reverend Horace Sanders Jr. is the current pastor. He explains that his primary mission and vision is to assist the realization of the unifying body of Christ as

love and support with one another, healthy relationships and attitudes that build people up so they may support stronger relationships, friendships, families and community.

Deaconess Linda Winston and her husband Deacon Hayes Winston are current church pillars. The Food Pantry service has been run by Dorothy Simms for the past thirteen years. Reverend Sanders led the celebrations of the fifty-fifth anniversary of the church congregation in 2007.

Refuge Church of Christ

Peekskill is fortunate to have a church building still in active use that dates from 1846. The Refuge Church of Christ at 831 Main Street was once the location of Peekskill's First Baptist Church, which is now located on Highland Avenue.

The Refuge Church of Christ began at Peekskill in 1951 and has been at its current location since 1956. Its congregation worships with music and callings to Christ. The current services attract primarily African American congregates who follow a service tradition with strong Christian themes. Bishop Curtis Brown is the pastor, with Louise Madden as administrator and treasurer.

The tall side windows provide a soft, pleasurable light through rare, bluish, pearl–colored marbleized glass. A small, arched alcove behind the altar highlights a vividly colored stained-glass depiction of Jesus that is a heavenly sight when illuminated.

Two Apostolic and an Evangelical Church

The Church of the Comforter is located at 1218 Park Street. The building was previously used by the AME Church. The Church of the Comforter has provided spirited and earnest ministry to those who wish to participate since 1986. Pastor David E. Robinson and Co-Pastor Elizabeth Robinson lead the congregation in ways that assist those in spiritual need.

The Christ Community Church is located at 1607 Main Street. It describes itself as an apostolic faith Bibleway worldwide church. The church pastor is Bishop Carey Robinson. The Christ Community Church was organized in 1972 and has been a vital spiritual center in Peekskill since that time.

The Final Hour End Time Deliverance Ministries occupies the former Hungarian Church on Kossuth Place off North Division Street. It is an Evangelical congregation, and is listed as Church #3.

Mount Olivet Baptist Church: Reverend Wiggins's Pastorate

Mount Olivet Church has been a vital center for community worship for more than a century, forcefully practicing and advocating life-affirming values. Reverend G. Franklin Wiggins, a native of North Carolina, was appointed the church's twelfth pastor in 1960, and he served with distinction for thirty-six years until his death in 1996. Reverend Wiggins led the physical expansion and modernization of the church's structure, while encouraging an extensive growth of affiliated groups and activities.

Within five years of the pastor's arrival, construction began on a new church building on Southard Avenue. Church activities soon expanded to include as many as thirty-five auxiliaries and boards, backed by a competent administration with a sound financial base. Among the many outstanding people who contributed their time and devotion were Amy Rabb, as mother of the church, Luther Dabbs and Steven Rose.

A peak year during Reverend Wiggins's pastorate was 1993, with the dedication of church-sponsored housing at 1621 Lincoln Terrace under the direction of Jackie R. Epps, president of the Mount Olivet Housing Development Fund Corporation. The

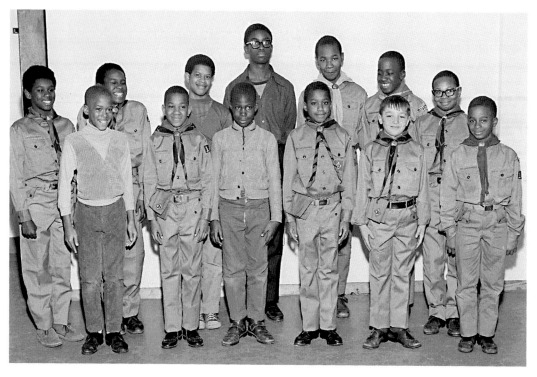

Mount Olivet's Boy Scout Troopers assembled for this photo in 1970.

hundredth-anniversary, full color commemorative booklet contains excellent portraits of church members at that time.

In recognition of Reverend Wiggins's many accomplishments in the community, Mayor Richard Jackson awarded him a symbolic "Key to the City" in 1985. The pastor was the first executive director of the Community Action Program, a Field Library trustee, the chairman of the Interfaith Council and a member of the City Human Relations Commission.

Reverend and Mrs. Wiggins's activities and influence reached well beyond Peekskill. They were present during the August 1963 March on Washington, centered at the Lincoln Memorial. This was the historic occasion of Dr. King's famous, eloquent and important "I Have a Dream" speech. The demands at that time were for effective civil rights legislation, school desegregation, an end to housing and employment discrimination and a job-training program. Reverend Wiggins was also active on the international scene as the keynote speaker in Johannesburg, South Africa, in a 1988 event sponsored by the Federal Independent Democratic Alliance.

The Reverend Wiggins Memorial Scholarship Fund was established to assist deserving high school seniors in further education. Mrs. Ida Silver Wiggins, a retired elementary teacher in the Lakeland School District, continues to be active and involved in a variety of community activities. Mrs. Wiggins visited the country of Ghana, West Africa, in 2001, where she helped build a library in a small village.

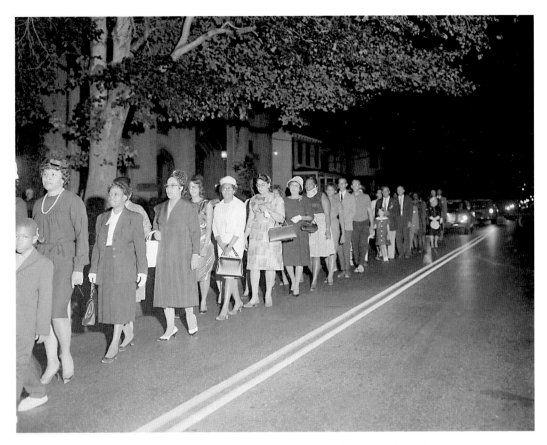

This evening sympathy march in September 1963 was for the small children killed in the Alabama church bombing.

In respect for Reverend Wiggins's many accomplishments and years of service to the Peekskill area, a portion of Southard Avenue between Main and Park Streets was renamed in his honor as the "Reverend G. Franklin Wiggins Plaza." The former pastor's wife remains active in the church, serving on several ministries, and she also serves on various community boards, including the Historic and Landmarks Preservation Board. She is accomplished in her own right and served as an advisor to a children's textbook publisher. Their children Bryan and Amy earned advanced college degrees and are employed professionals.

Dr. Adolphus C. Lacey is the church's dynamic present pastor. His Sunday morning services sparkle with intellectual passion and Baptist sincerity. Reverend Lacey has been able to fulfill an ongoing negotiation for the purchase of the former Park Street School from the school district. Located just across the street from Mount Olivet Church, the former school may be used for a variety of religious and community activities. The pastor also announced in 2007 a goal of raising funds to build a new church structure.

Haywood Burns would choose among scholarships to three top colleges while at PHS in 1958. He chose Harvard College.

Haywood Burns Influenced the World

Haywood Burns was a shining intellectual star at Peekskill High School in the 1950s. If one types in the term "Haywood Burns" in an Internet search engine, she will find that this one man has an amazing record, including a position as dean of CUNY Law School with a chair in civil rights named in his honor.

One may also find online the W. Haywood Burns Environmental Education Center detailing his life activities. Born in Peekskill in 1940, Haywood received a four-year Harvard scholarship after graduating from PHS in 1958. He studied law with an eye toward social justice. The Harvard College community at that time included only ten African Americans among a thousand other students.

Burns later studied for a year at Cambridge College in England. Always keenly aware of how people are treated differently according to their skin color, and how laws tended to reinforce these inequalities, his mission as a lawyer was to change and correct these injustices. He published a pamphlet, "Voices of Negro Protest in America," in 1963. He taught a class at New York University Law School titled "Racism and American Law." He pointed out how labor unions, home ownership and higher education were legally rigged against colored minorities in the 1950s and '60s. He also worked for a while as a legal counselor to Dr. King.

Haywood Burns was the general counsel for Dr. King's Poor People's Campaign. Mr. Burns also founded the National Conference of Black Lawyers in 1969.

Putting his own words into action, Haywood Burns turned his talents to official racial separation, known as "apartheid," in South Africa. After meeting future South African president Nelson Mandela in Harlem, Burns was a legal advisor in drafting South Africa's Interim Constitution. Later, he became personally involved in that country's political reorganization.

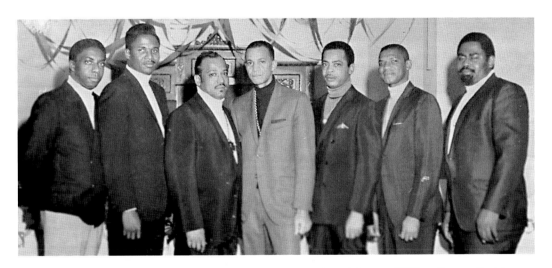

"The Esquires," organized in 1969, were from, left to right: Business Manager William Graves, Social Director Lee Burns, President Thomas Willis, James Brown, Secretary Robert Warren, Treasurer James Roberts and Sergeant at Arms Herbert Barrett.

The Socialite Club
members of April
1969. Pictured left
to right are Abe
Alston, Sam Bostic,
Willie Winston, Sam
Steward, Walter
Southall and Claude
Allen.

As one of Peekskill's brightest individuals established a connection with the country of South Africa, it was fitting that Archbishop Desmond Tutu visited Peekskill in October 1992 and spoke during a service at St. Peter's Episcopal Church on North Division Street.

Then came a shocking news headline in April 1996: "Noted Attorney Haywood Burns Dies in Car Crash." While attending a law conference in South Africa, a traffic accident resulted in his death.

The *New York Daily News* reported: "Activist Burns Eulogized as Rights Pioneer." The night before his accident, Burns had called his wife to say that hearing South African President Mandela's address to Parliament was "the proudest and happiest day of [his] life."

Haywood Burns's Harlem funeral service at Abyssinian Baptist Church was attended by twenty-five hundred people, including former New York City mayor David Dinkins. He was selected for the PHS Hall of Honor and was honored in a memoriam by the Peekskill City Council in the year 2008.

Taking Charge and Moving Ahead

Zeta Phi Beta Sorority: Nu Psi Zeta Chapter

The Peekskill Chapter of the national Zeta Phi Beta sorority is the Nu Psi Zeta, organized here in 1987. The members are women with college degrees of all levels. Their regional theme is: "We make a difference because we dare to be different."

The first Zeta Phi Beta sorority began at Howard University in 1920 in affiliation with the Phi Beta Sigma fraternity. Its goals and efforts are charitable, informational and corrective. This Peekskill women's organization has awarded thousands of dollars in scholarships to deserving PHS seniors and has sponsored Finer Womanhood Award luncheons.

Active in the sorority have been Shirley Jackson, Bevelyn Grindle, Trudy Stewart, Ann Lemon, Eartha Brown, Kim Harrison, Leverne Davis, Jennie Harrison, Tina Washington, Cheryl Pemberton, Joanne Johnson, Lelithe Smith, Trudy Stewart and many others through the years.

The Archonettes are high school girls who are interested in community service, scholarship and mutual harmony. They have volunteered with the American Heart Association, the VA Hospital and the health center. The Archonettes' choir performs at sorority events.

Peekskill Firsts

Pamela Roberts-Beach

Pamela Roberts-Beach has handled all matters in a professional and capable manner as Peekskill city clerk since 1989. She set two historic firsts as the youngest person to serve as municipal clerk in Westchester County and as the county's first African American woman to fill this office.

Mrs. Leola Gaines was the first woman to work as a linotype machine operator at the *Peekskill Evening Star* newspaper in 1973.

Efficient, assertive and exacting, Pamela is especially proud of her daughter's recent accomplishments in earning a law degree in 2007. Louise Kellie Beach is a graduate of Assumption School, PHS and Hofstra Law School and now practices law in Purchase, New York.

Pam's mother, Anna Mae Roberts, was a dynamic activist who was former president of the Peekskill Chapter of NAACP, a Peekskill Housing Authority board member, a Sunday school teacher at St. Peter's, a social worker for Coordinated Human Services and a day care teacher at Peekskill Head Start.

Geraldine Kearse

Friendly, bright and cheerful, Gerry was the first African American woman to work at the Peekskill Post Office. She went on to serve as postmaster at Granite Springs for one year. Gerry Kearse then worked as postmaster at Crompond Post Office for a distinguished eighteen years until she retired in 2003. Her daughter Renee is a special education teacher at Peekskill High School.

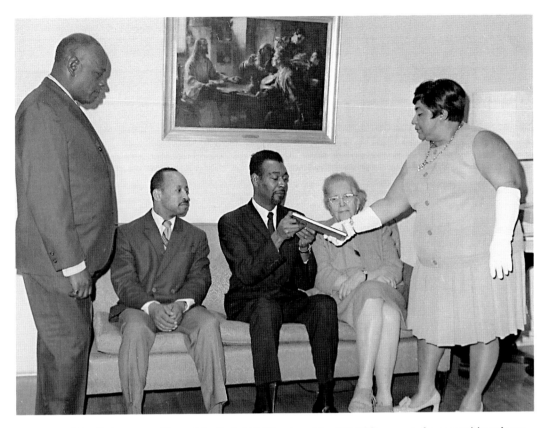

Mrs. Anna Mae Roberts, president of the Peekskill Chapter of the NAACP, presented a recognition plaque to the Charitable Six in 1970. Receiving the plaque was Leroy Hankins. Coleman Smith is pictured seated, and David Whitfield Jr. is standing.

Coleman Smith Jr.

Wanting to lend a helping hand in his own city, Coleman Smith attempted to join the Peekskill Fire Department in 1963, but he met with considerable difficulty. His application for membership into the Columbian Hose Company was not accepted. When asked, the firemen refused to discuss the issue and the reasons for their decision.

In response, the local NAACP, under Melvin Tapley, advocated withholding city taxes until "the discriminatory practices of the Peekskill Fire Department have been corrected." Pursuing the matter further, a letter from the assistant attorney general of New York State reminded everyone of the legal provisions that protected against consideration of one's race, religion, gender or national origin in accepting fire company members.

Coleman Smith Jr. was eventually elected to membership in the Cortlandt Hook and Ladder Company in 1965. A U.S. Navy veteran, he was later selected for the Peekskill Housing Authority board of directors in 1981. Mr. Smith served as a local Democratic Party district leader for many years and was a valuable member of the Charitable Six. His wife is the former Miss Vera Tinsley.

Renee Smith of Peekskill was the sole African American girl to graduate from St. Mary's School in 1971.

Their daughter Renee M. Smith was the only African American student in her class at the former St. Mary's School for Girls. Renee has recently written some articles printed in the *Westchester Guardian* magazine that are clearly focused and sharply worded concerning Peekskill issues, such as the release of Jeffery Deskovic after enduring fifteen imprisoned years of his life for a crime he did not commit.

Her November 2007 article, "Mary Foster and the Democrats Make Political History in Peekskill," is an interesting analysis of the differences and tensions between local Republicans and Democrats that helped influence the election results.

Charles Bolden

City Councilman Melvin Bolden Jr.'s grandfather and Melvin T. Bolden's father, Charles Bolden, was the first African American officer to be employed by the Peekskill Police Department in the early 1950s.

Born at Peekskill in 1918, Charles Bolden attended local public schools and then continued his education at Howard University. He graduated with an education degree from West Virginia State College, where he met Jesse Choice, whom he married in 1940. When World War II came along, Mr. Bolden served as a warrant officer in the U.S. Army and saw action in wartime Europe.

Mrs. Pearl Rowe worked as Peekskill's new meter maid in February 1969.

As a policeman, Charles Bolden received a Red Cross Award, for saving someone's life, and the Crispus Attucks Award, for distinguished service. He was also honored as Father of the Year. A friendly, quiet, determined man, who was devoted to his family and community, Charles Bolden was a member of Mount Olivet Baptist Church and the NAACP.

He was a lifelong friend of Caleb Peterson, the Peekskill singer who went on to Hollywood film production.

Peekskill Area Health Center

The original Peekskill Area Health Center on Main Street, recently renamed Hudson River Healthcare, was started primarily by four African American women: Reverend Jeanette Phillips, Willie Mae Jackson, Pearl Woods and Mrs. Mary Woods.

Frustrated with the level of healthcare available to their own families in the 1960s and '70s, they worked to establish a downtown center where affordable medical and dental health prevention and treatment would be available to the Peekskill community. The founders remained as health center administrators for many years. Community leader Mary Rainey, as director of the Community Action Program, was also concerned about the lack of a local healthcare clinic.

After consulting with Westchester Health Department officials, the founders received a $285,000 grant for rent, supplies and staff starting in 1975. Their efforts from the beginning to the present have been a spectacular success.

Hudson River Healthcare now provides services to about seventeen thousand people a year. Its success has promoted expansion to satellite health centers in Putnam, Rockland, Dutchess and Ulster Counties.

The current budget is $15.5 million. Anne Kauffman Nolan is the current president of its board, and Jeanette Phillips is executive vice-president. The "founding mothers" of the health center were NAACP members and were supported in their efforts by that organization.

Family Resource Center

Mrs. Vera McCorvey was the inspiration and driving force behind the Family Resource Center from its start in 1993. Now run by Vera's daughter, Elizabeth McCorvey, the North Division Street center has filled a constant need for housing, food and counseling.

The center has assisted five hundred families in the Peekskill area, as well as providing twenty-two housing units for low-income families. Its Harvest Program has helped with food, clothing and furniture.

The Family Resource Center also helps first-time homebuyers who try to work their way through the many financial and legal aspects of owning a home such as credit, down payments and so on. Although Vera McCorvey passed away in 2007, her legacy of caring assistance will certainly endure.

Aunt Bessie's Open Door Day Care Center

Mrs. Bessie Hargrove was a driving force and inspiration for the creation of Aunt Bessie's Open Door Day Care Center, now at 137 Union Avenue. Aunt Bessie's day care story dates back to 1968, when it was first located on Lelia Street and then moved to a Main Street storefront. It relocated to the former Methodist parsonage on South Street, where Franciscan friars at Graymoor offered support, and finally moved to its current location.

Originally a completely volunteer operation that relied on donations of time, skill and material, Mrs. Hargrove attracted Pauline Hinton, Eloise Broadway, Susan Thatcher and Harnetha Lewis as dedicated workers for many years.

A historical sketch, *As Long As There's a Door*, written by board member Susan Thatcher, explains the long process of managing this facility. Ms. Thatcher is a consultant in occupational therapy for the Sullivan County Association of Retarded Children. Mrs. Harnetha Lewis (to whom Bessie Hargrove was a genuine aunt, being Harnetha's father's sister) provided Ms. Thatcher's material:

Mrs. Bessie Hargrove is pictured standing, second from the left, during a 1971 event marking the twenty-fifth anniversary of the Peekskill Improvement Society. To her left is Mrs. Harnetha Lewis.

A dinner dance benefit for Aunt Bessie's was held in October 1969. Pictured at left is Mrs. Benny Goodman, at center Mrs. McCaskill and at right Mrs. Fred Barnard.

The single unifying factor that drew the original mixed bag of founders together was the lady herself, Aunt Bessie, sometimes called Mrs. Hargrove, who had already been providing child care services in her home for 20 years…The core of the center was a transplant from Aunt Bessie's own backyard where she had built a playhouse and managed her own day care center for years using volunteer teachers.

Mrs. Pauline Hinton said about Mrs. Hargrove, a South Carolina native who died in 1979: "She had no children of her own, but she helped raise hundreds. She was a wonderful lady." A major transition took place when the quality day care offered by volunteers required a professional paid staff starting in 1974. While it lost some independence, it gained more reliable financial support with a regulated professionalism.

Aunt Bessie's was once available to children of all ages who dropped by and were welcome through the open door. Help with afterschool homework, trips to Mount Florence on Maple Avenue and a trip to Washington, D.C., were among their many activities.

Now a fully incorporated day care center with a director and paid staff, Aunt Bessie's Open-Door Day Care Center remains a valuable community resource. It serves forty-four children between the ages of two months to six years.

Human Relations Commission

Peekskill Human Relations Commission has, since 1964, worked to bring religious, racial and cultural understanding and harmony to the larger community.

Former Commission members have been James Lemon, Jacob Paige, Brenda Undly, Reverend Floyd Warren and Mrs. Irene Jones. Mary McDowell has been a commission member for the past seven years.

One encompassing way to create community understanding and harmony is to highlight something that everyone shares, such as love for pets. The Peekskill Human Relations Commission sponsored a "Pooch Fashion Parade" event in 2007 at Riverfront Green in collaboration with weatherman Joe Rao from cable news station Channel 12.

Politicians

Peekskill's first village election was held in 1826. It wasn't until 1980 that our first African American citizen was elected to either the village or city council.

Richard E. Jackson Jr.

Elected to the common council in 1980 and then reelected in 1984, Richard Jackson has deep Peekskill roots. A PHS graduate from the Class of 1963, he worked for nearly thirty years (1968–1994) as a high school math teacher. His father was the Peekskill

Water Board superintendent. His grandfather, George Jackson, once headed the local housing authority.

Richard was selected to fill the remaining term of his former high school classmate when Mayor George Pataki moved on to higher office in 1984. Mr. Jackson was reelected three times as mayor in his own right. Well known and well liked, Richard Jackson won elections for mayor in 1985, 1987 and 1989. He resigned in 1991, but was elected to the council again in 1993. When Pataki became governor in 1994, Richard was nominated and served as commissioner of motor vehicles for several years.

Richard Jackson succeeded in several firsts, becoming our first black councilman and then both Peekskill and New York State's first African American mayor. Questions were often asked about how he saw his role in government and how race affected his thinking in politics. A *Journal News* article written by Oliver W. Prichard includes a quotation from Mr. Jackson responding to these issues: "That is to say that not everyone of the same race thinks the same way. There is divergence within a race."

William Johnson

Bill served on the city council from 1990 to 1994, and as a deputy mayor to Frances Gibbs. Mr. Johnson was an admirable basketball and track team member at PHS. He established a professional photography business downtown that was successful for three decades.

Appropriately framed beside his work, William Johnson opened his photography studio above Weeks Jewelry Store in 1973. Bill operated his shop for many years on Main Street.

His family relocated from Georgia, and Bill's mother is Juanita Jackson of Scott's Beauty Salon. His daughters Kelly and Karen are employed in responsible jobs within corporate and academic organizations, respectively.

Somewhat frustrated by politics, Bill Johnson has always been a quiet and reasonable voice when civic situations seem to spin out of control. His patient and careful approach to issues has not always been properly appreciated within civic circles. He was honored for his services by the Peekskill City Council in 2008.

Alonzo Undly

Mr. Undly is a PHS graduate from the Class of 1958. He was elected and served on the city council starting in the 1990s. He was appointed deputy mayor to Mayors John Kelly and John Testa. Al was influential in getting the renovations to the Kiley Center underway.

Al Undly is a U.S. Marine Corps veteran. He retired from his position as a systems programmer with IBM after about thirty years. Al's father was Sylvester Undly, a navy veteran of World War II.

The councilman's son, Alonzo Undly Jr., is an intellectually curious young man who has worked for the city while holding forums and readings and sampling various writing styles such as poetry and screenwriting.

Donald Bennett Jr.

Don is a community-minded person who came to Peekskill as general manager of the downtown Steinbach's department store that had previously been Howland's and Genung's. In addition to being employed as an advertising representative with Pamal Broadcasting, which operates radio stations WHUD and WLNA, Don ran for mayor in 2005. He has served on the common council since his election in 2003, he was reelected in 2007 and he was selected deputy mayor in 2008.

Originally from Baltimore, Maryland, Don Bennett was president of the Peekskill Rotary Club in 2000–01 and was active with the Hudson Valley Gateway Chamber of Commerce. He was selected as Man of the Year for community service in 1992 by the local chapter of Zeta Phi Beta sorority. Mr. Bennett was also honored for his activities by the Peekskill NAACP at its 2007 banquet.

Don's wife Rose passed away in 2003. Their son Damon is an army captain who has been posted at several overseas locations such as Korea, Germany and the Middle East.

Melvin C. Bolden

Mr. Bolden was elected to the Peekskill Common Council in 1999 and served until 2008. He is proud to represent the fifth generation of his family to be involved with the Peekskill community. Mel has set a historical record as the youngest African American Republican ever elected to a government office, and he was elected to the PHS Hall of Honor.

Melvin works as a music and technology teacher at Peekskill Middle School and was advisor to the Black Culture Club. He is the principal talent behind his Mel B. Production music company, and is a member of the Peekskill Fire Department and former captain at Columbian Engine Co.

Published Memoir by Ethel Jackson

My Memories of 100 African American Peekskill Families

Mrs. Ethel L. Jackson's published memoir of 1997 is an important archive for local African American history. Working entirely from her own amazingly accurate and comprehensive memory, Mrs. Jackson considered this book to be a highlight of her life shortly before her death at age ninety-three.

Working for four decades as a licensed practical nurse, she summed up her experiences with these words: "I love Peekskill, and have had a very nice life. By telling my story, I am leaving a legacy." Not every family is mentioned in her alphabetical list, but taken altogether the memoir is a wealth of information that has never before been published and is now available as a public resource.

The cover photograph of *My Memories* highlights Mr. Isaiah Hughes, nicknamed "Button," as the paid fire driver for Washington Engine No. 2 when the fire station was located on Nelson Avenue (1890–1910). Handling that fire engine and its two-horse team for a span of twenty years was an accomplishment for anyone at any time. That Isaiah Hughes performed this challenging job with a Peekskill fire company so well for so long as an American man of African descent is certainly a noteworthy part of community history.

Experiencing the *Amistad*

A physical artifact, or even a reproduction of a genuine object, helps explain the people and circumstances associated with it. The *Amistad* incident of 1839 attracted international attention.

On July 2, 1839, the Spanish ship *Amistad* was transporting captive Africans from Havana, Cuba. Led by a man named Joseph Cinqué (Sengbe Pieh), the fifty-four Africans on board rebelled and took over the ship. The captain and several crewmembers were killed in the process. In attempting to sail back to Africa, the ship took a turn into Long Island Sound, where it was sighted and its passengers wound up being detained in a jail. The story of the men and their actions aboard the *Amistad* received wide publicity.

Several appeals were made to U.S. courts. At a Supreme Court hearing in 1841, former U.S. President John Quincy Adams argued that the slave trade was already illegal in Spain and the United States and therefore their capture and transport on the *Amistad* was also illegal. The captives were freed and went back to their homes in Africa.

As a visible hands-on way of drawing attention to the realities of African American history, the $3 million ship replica was docked at Charles Point Park for public tours in June 2001. Offie Wortham of Peekskill was able to negotiate a $1,000 donation from singer Pete Seeger to organize a bus trip to attend the initial launching of the *Amistad* replica at Mystic, Connecticut.

Community Leaders: 1970 to 2000

When the turmoil and tension of the 1960s and early '70s eased, the daily work of raising families, obtaining education and employment and building a community took center stage. This was the era in which the Lyndon Johnson administration sponsored Head Start, VISTA, the Community Action Program (CAP) and other such "war on poverty" programs.

Dr. James Pickward Bash, anesthesiologist at Peekskill Hospital, was honored by the local Kiwanis Club for his community service in 1967.

There was no hiding Debbie Jackson's beauty as Miss Peekskill in July 1973 as she paraded through the downtown.

Several outstanding leaders, both male and female, emerged, able and willing to build the consensus necessary for successful action leading to satisfying results. Several longtime African American families had carved a place for themselves within the larger Peekskill community during the previous century. With an increase in the local black population, a true African American community began to define and assert itself in the mid-1970s.

Considerable progress in employment, housing, education, politics, media and various community boards was made through the 1980s and '90s. Several African American initiatives still have had a deep and ongoing influence in Peekskill. Some people's names and faces appeared over and over again in dealing with necessary issues as they arose. As such, they are historically significant and need to be mentioned.

Melvin S. Tapley

Melvin Tapley (PHS Class of 1935) distinguished himself as an accomplished editor, artist and pioneer cartoonist as arts and entertainment editor of the *Amsterdam News* in New York City until his retirement in 1997. Mr. Tapley was president of the local NAACP chapter for eleven years until he resigned in 1968. He twice invited Mrs.

Eleanor Roosevelt to speak on race relations at Mount Olivet Church in the 1950s. His wife Arlene, director of the CAP office, took over as president.

Melvin Tapley was the first African American to run for the Peekskill school board while a member of the citizens' advisory committee. Their daughter, Allison Tapley Thompson, who has a background in science education, is an active member and historian for Mount Olivet Church.

While on the subject of local artists, Jerry Pinkney has accomplished distinguished artist work in several mediums. Raymond Brown, Peter Foster, Andrew Just, Roosevelt Stokes and Sterling Stokes are among Peekskill's contemporary African American artists of note. Ossining artist Betsy Braun Lane has actively promoted Peekskill's African American history with focused exhibitions in Peekskill, New Rochelle and elsewhere.

Mrs. Jessie Bolden

Mrs. Bolden has been a dynamic community leader, with a BS degree as a backup, and she is as sharp as ever at ninety-plus years of age at the time of this writing. She was available to campaign for the first African American person elected to the school board and city council, and to serve in responsible positions with the NAACP and health center. The Councilman Melvin Bolden Jr. is her grandson.

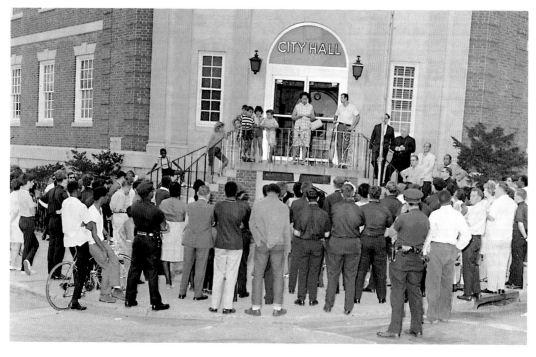

Mrs. Jessie Bolden addressed a rally in front of city hall urging the appointment of a black councilman on July 15, 1968

As health center president, she sponsored the first Culinary Arts Festival at Riverfront Green Park in 1979. The centerpiece was an omelet using 10,472 eggs that earned its listing in the *Guinness Book of World Records.*

Walter Corney

As busy as Charles and Jesse Bolden were in raising their own family (sons Charles Jr., Melvin and Barry) on Wells Street, they also took in several foster children. Treated as a member of the family, Mr. Walter Corney fulfilled his life as a coach and instructor.

Local media teacher and videographer Doug Brown produced *An Interview with Mr. Corney* in the year 2000. This valuable video is a long look at Walter Corney's many activities and skills as a professional sports coach with young people. Camera clips include Jim Robinson, Pearl Woods, Freddie Spry Jr., Tyrone Welch, Jacqueline Corney, Elliot Artis, Harry Mosley, Melvin T. Bolden, Mrs. Jessie Bolden, Jackie Patton, Mary Rainey and of course Walter Corney himself.

Busy with athletic education and sports recreation from 1967 to 1999, Mr. Corney spoke of the Boys Club once at Park Street School, the Highlighters men's softball team, the Centralities girls' softball team and the Youth Canteen at the Kiley Center. While employed at the VA Hospital in Montrose for thirty-seven years, Mr. Corney coached track, basketball, baseball, softball, football, boxing and soccer.

Testimonials and personal interviews reveal that Mr. Walter Corney was an exceptional person devoted to training and guiding young people in sportsman-like values, often sacrificing time with his own family for this work. The Walter Corney Gymnasium in the Kiley Center is dedicated to his great work in sports education.

Mrs. Cleopatra Jones

Mrs. Jones was once the head of the NAACP. She retired from that position in 1982, after serving the organization in various activities for about fifty years. She helped raise twenty-two children, including twelve foster children.

The North Carolina native was a founder of the Peekskill Area Health Center. She and her husband owned Montrose Coal and Fuel Company for fifty years. Kevin Bunch carried on as head of the company after his father passed away. Bobby Bunch has excelled at academic studies and earned two doctorate degrees.

Offie Wortham

Offie Wortham and Haywood Burns were buddies during their time together at Peekskill schools. When Haywood challenged Offie for the office of president of Peekskill NAACP Youth Council (1954–58), Offie commented, "It was the only thing Haywood ever lost."

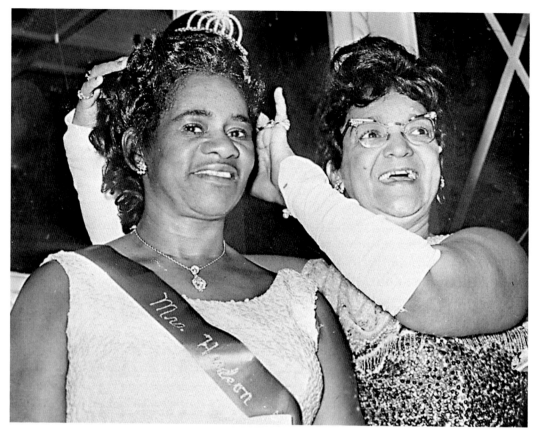

Mrs. Cleopatra Jones of Montrose was crowned queen of the Woman's Club Convention held at Albany in July 1968. The woman at right is Mrs. E. Lett Dixon, the first vice-president of the convention.

The local organization grew into the largest NAACP Youth Council in the nation, with over four hundred members. Offie Wortham moved on with the NAACP Youth Council to county- and state-level organizations while working in the IBM apprenticeship program in computer electronics.

He became the first and only person of color in the IBM Blue Sky research facility in Poughkeepsie, New York. This was the most advanced computer research laboratory in the United States. He was a research assistant with his own room, and he conducted innovative experiments on thin films that became the basis for microchips.

Civil rights issues were always his central interest, however. He was affiliated with Bayard Rustin, A. Phillip Randolph, Jackie Robinson, Roy Wilkens and Dr. King in the 1950s, when he was selected to join a delegation of eight led by Harry Belafonte to meet with President Eisenhower at the White House in 1958.

Offie has received his bachelor's, master's and doctorate degrees. While attending Antioch College in Ohio, where he majored in physics, he formed the Antioch Civil Rights Organization. This organization grew to include seven hundred paid members, of which 95 percent were white. This was the largest college NAACP chapter and civil

rights organization on any campus during the civil rights movement. The organization successfully spearheaded desegregation of movie theaters, barbershops, skating rinks, bowling allies and restaurants across Ohio.

Mr. Offie Wortham was born in Peekskill in 1938. His sister is Pauline Hinton. Their father, Lloyd Bell Wortham, was born in Peekskill in 1900 and graduated from PHS in 1917. Offie's grandfather, William Wortham, was once the coachman for Dean Ferris, who ran a greenhouse and flower business. Offie and his wife Vivian now live in Vermont, where Offie is a psychotherapist, life coach and travel consultant.

Vivian Wortham

The former Miss Vivian Hooks rates mention in her own right. Her work with a Saturday arts and crafts program at Mount Olivet Baptist Church brought her into contact with Steven Rabb, who was there as a child. Mr. Rabb is now a teacher with the Peekskill School District.

While active as a Northern woman in a Head Start organization in Mississippi, there were plenty of real and potential dangers, from which she escaped one time in the back of a Volkswagen. Vivian later worked with Head Start programs in Harlem. She became a teacher and director of the National Black Theatre Children's School. She also wrote a play that was performed across the country. One of Vivian's first child actors was Donald Faison, who has appeared on *Scrubs*, *Clueless* and other popular television shows.

Mrs. Wortham started her own summer camp. The Learning Safari took children from the Harlem community to Seattle, Washington, D.C., and many other historical sites as an educational travel program. She also taught at an all-black private school in Harlem founded by Mildred Johnson, who was niece to James Weldon Johnson, the author of the hymn "Lift Every Voice and Sing."

Vivian now has an educational travel camp for children. As a writer, she is finishing up a play about George Washington Carver and is in the process of publishing several children's book.

Jeanette Phillips

Jeanette Phillips helped organize the Peekskill Area Health Center and has remained active in various administrative jobs, now serving as executive vice-president of Hudson River Healthcare.

Arriving in Peekskill from Harlem in the 1950s, Ms. Phillips is also director of the Preservation Company, which assists low-income homeowners with thirty-two grants a year to fix up their houses. She is a deacon and elder at the AME Zion Church. The city council authorized "Jeanette Phillips Month" in 2006 in recognition of her many contributions to the community.

Cordell W. Johnson

Cordell Johnson once served as president of the board of directors at Paramount Center. He applied his scientific background as a research chemist and laboratory supervisor at the former Mearl Corporation in Ossining. Mr. Johnson has been a leader at the Mount Olivet Baptist Church and the local NAACP.

C. Harnetha Lewis

C. Harnetha Lewis, who now lives in New Jersey, has been intensely interested and involved in the education of her children. Her three girls graduated from Peekskill High School, and her son graduated from Storm King School in Cornwall, New York.

Mrs. Lewis was a dynamic force in several community organizations while raising her family and working at a full-time job. She served for seven years on the Peekskill school board, including roles as vice-president and president. She was a prime mover and shaper of Aunt Bessie's Open Door Day Care Center during its difficult early days. Ms. Lewis had a special interest in the day care organization, as Bessie Hargrove was her aunt. She also served as Aunt Bessie's treasurer and as a board member.

Ms. Lewis worked for thirty years in her career as equal opportunity employment specialist at West Point. She twice invited the West Point Gospel Choir to sing at Mount Olivet Church, where she started several helpful programs. A $4,000 book fund bearing her name was created at the Uriah Hill School in 2001 as the C. Harnetha Lewis Children's Book Fund.

Notable Educators

Black educators began teaching with the Peekskill School District only in the late 1950s and early 1960s.

Vernon Walters

Mr. Walters was a pioneer as the first African American to be hired in Peekskill. He worked at the Uriah Hill Elementary School starting in 1957. A Peekskill native, Mr. Walters graduated from Plattsburg, and after his army service he joined this district in 1957. Even his hiring was problematic. A split vote by the board of education was broken by the vote of its only black member at that time, Reverend Taylor.

Mr. Walters went on to break the color barrier in Irvington as the first black teacher in that district. He worked his way on to become the first African American principal at both Elmsford and Brewster School Districts. He retired from his position as assistant superintendent for personnel at Brewster in 1991.

PHS Employees

Paul Lewis taught algebra and Shirley McPherson was librarian at Peekskill High School in the early 1960s. By 1978, Wanda Timberlake was teaching high school English and Sidney Crispell was a mathematics teacher. Jacqueline Blue was secretary in the vice-principal's office in the 1970s.

Hank Kearsley and Eugene Chapman

The Drum Hill Junior High School was where Hank Kearsley taught art classes in the early 1960s, and Eugene Chapman became a science teacher there.

James B. Taylor Jr.

Mr. Taylor is now retired, but he remains busy and involved with the Peekskill community in several ways. He accomplished twenty-eight years of distinguished service with the Peekskill School District. After working as a fifth-grade teacher at Oakside, he served for nine years as that school's principal. He also worked as principal at the Uriah Hill School and was assistant principal at PHS for a while.

His wife is Judith Moshier, daughter of Mrs. Kathleen Moshier. They are very much involved with St. Peter's Church, and Jim has taken on a large responsibility in trying to preserve the old, 1750s St. Peter's Church in Van Cortlandtville. James Taylor volunteered for many years with the National Guard Youth Brigade known as "Peterson's Patriots." They would drill at the state armory on Washington Street and learn various specialized skills.

Knowledgeable about all aspects of African American history, Jim Taylor currently performs an educational role by reenacting the activities of a slave freed shortly after the Revolutionary War at the Philipsburg Manor historic site in Sleepy Hollow, renamed from North Tarrytown. His innovative program is titled "A Bucket Full of History." Dressed in clothing authentic to his reenactment time period and using tools that were available two centuries ago, Mr. Taylor demonstrates the woodworking skills, tools and materials that a cooper workman used in making barrels, buckets and utensils as household and industrial items.

He provides a personal, engaging and vivid demonstration of an enslaved person's daily life during the colonial era and the ways in which many black Americans learned and practiced skills useful to their own lives in these conditions.

This type of living history becomes an education as much for the actor as for the spectators. Life in the Hudson Valley more than two hundred years ago is very different from life in our modern technological world. Yet, in some essential human ways, life now and then is very much the same. Jim Taylor is keenly and subtly aware of these realities as he performs his tasks on the manor land of long ago.

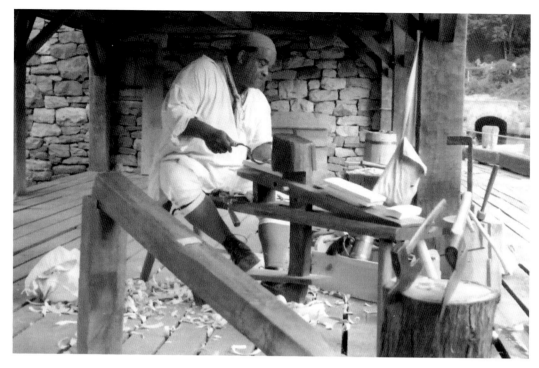

James Taylor, a retired Peekskill elementary school principal, reenacts the role of a skilled slave living shortly after the Revolutionary War. His educational program at the Phillipsburg Manor historic site is titled "A Bucket Bull of History."

Delores Jones

Ms. Jones served four years as principal of Park Street Alternative School until 1996, after teaching for fifteen years within the Peekskill School District.

James Baten

Mr. Baten became Oakside School and Peekskill's first African American principal in 1972. He initiated the all-day kindergarten and pre-school program in the district.

Edward Dickerson III

Mr. Dickerson, who passed away in year 2000, has left his mark on the Peekskill Middle School library, named in his honor, where he worked for many years as a teacher and assistant principal.

Steven Rose

Mr. Rose is a PHS graduate who diligently worked for forty years as a social studies and history teacher, beginning in 1968, at Peekskill Middle School until his recent retirement

in 2007. Mr. Rose became the first black president of the Peekskill Faculty Association and served for thirteen years on that board.

Steve has been actively involved in his community as an NAACP member, a human relations committee member, a board member of the Field Library and zoning boards and he served on the Mount Olivet Church deacon's ministry.

Mr. Rose was honored during Black History Month by the Peekskill City Council in 2007 with a proclamation recognizing his efforts in the community. Also honored were Jeanette Phillips, Willie Mae Jackson, Mary Woods and the late Pearl Woods. Ms. Woods was a Peekskill native who was quite active in many community organizations such as the housing authority and the Kiley Center.

Jennie Harrison

Jennie Harrison is a retired special education teacher at PHS. She also advised many honor students who needed financial assistance for college expenses.

In recognition of her membership in the ZIIP foundation (Zeta Interested in People), a yearly, monetary Jennie Harrison Award is presented. ZIIP has been a sponsor of the local Kwanzaa celebration with arts and crafts, food, music and dance in expressions of African unity.

In collaboration with the March of Dimes and the Hudson Valley Health Care Center, the Stork Nest program offers free prenatal care. Ms. Harrison has taken her experience with Zeta Phi Beta sorority in several community support directions.

Aisah Sales

Aisah Sales is a retired PHS math teacher who was an advisor to the Black Culture Club, which was started by Carlos Butler at the high school in 1980.

The afterschool program offers a variety of interests related to African American culture. Club members experience history, food, music, dance and talent shows with a focus on continuing their education at the collegiate level. A high percentage of Black Culture Club members succeed in entering colleges and universities.

PHS Educators

By the 1980s, PHS employed several outstanding teachers. Ruth Cooly taught special education and Joseph Tibbs taught industrial arts. James Smith started as a high school counselor and social studies teacher in the 2000s. C. David Ferguson was assistant principal at PHS in the mid-1990s.

In 2003, Jasper Cain was assistant principal at the high school, also working with S. Cummings in social studies, A. Jackson at physical education, K. Haskins in business, P. Hamilton in the music department and S. Priest in English. S. Stewart was in guidance and J. Clark worked in the office. Lynette Harris was assistant principal in 2005.

Dr. Judith Johnson

Brooklyn-born Dr. Judith Johnson has been Peekskill school superintendent since 2001. She was previously the assistant secretary for elementary and secondary education in Washington, D.C.

Some of her achievements have been the voter passage of a $59.8 million bond for constructing a new middle school, beginning a new dress code policy for all students in 2007 and instituting new course offerings such as meteorology, forensic science, astronomy, business and scientific research.

Norma Johnson, Steve Rose and Ruby Richardson

Norma Johnson was a middle school English teacher. Steve Rose started in 1968 and taught social studies and history until his recent retirement. Ruby Richardson was a middle school dental hygienist.

Elementary Schoolteachers

Elementary schoolteachers have included Anne Lemon at Uriah Hill; Mary Givens and Mary Duren at Oakside; and Sedonia Miller at Woodside. Vernon Rivers was the first black teacher at the Uriah Hill School.

Custodians

Memorable custodians at Peekskill High School have been Mr. Coleman Smith and Mr. George McCrea, both from Peekskill families. Richard McCrae and Edward Bowman were Peekskill school custodians. Mr. Bowman was also the first African American member of the Peekskill Ambulance Corps.

School Board

The first African American representative to sit on the Peekskill School Board was Reverend Carl Taylor. Melvin Tapley and John McIver were also elected to the position.

Valerie Jamison was elected to the board in 1986 and was selected as president in 1989. Valerie Bynum-Jennings was elected to the Peekskill Board of Education, and was its elected president in 1991. Mrs. C. Harnetha Lewis served on the school board from 1991 to 1997, becoming vice-president and then board president. Ralph Oliver Jr. and Maria Veliz-Green have been school board members for several years.

Current members include former board president Tuesday Paige McDonald (PHS Class of 1983) and Michael Simpkins, who has been on the board since 2002 and is now board vice-president. Ms. Tuesday McDonald's recent CD is a strong

and heartfelt rendition of traditional spirituals delivered in professional musical compositions.

Peekskill High School Hall of Honor

If they have not otherwise been mentioned, several outstanding Peekskill High School graduates were selected for the alumni Hall of Honor. A committee mostly in co-sponsorship with the high school Parents' Club presented its awards between 1995 and 2005. This committee has awarded more than eighty scholarships for $500 each from these activities.

The Peekskill Alumni Hall of Honor committee members were Ann Brady, Janine DeChristopher, Norma Johnson, Lisa Kontos, Richard Kontos, Vivian Miller, Elaine Mule, Catherine Pisani and Vera Smith. Approximately $40,000 in scholarships were contributed to high school students for their further education.

Henry E. Dabbs, Class of 1951

Mr. Dabbs's paintings of African American heritage have been displayed at the Smithsonian Institution in Washington, D.C., for more than twenty years. Commercial advertising designer, writer and film director are among his other accomplishments. Henry E. Dabbs is author of the 1984 publication, *Black Brass, Black Generals and Admirals in the Armed Forces of the United States.*

Loretta M. Bunch Kearsley, Class of 1952

Most of Loretta's professional life was spent in public health and education as a registered nurse. She also served on boards of the YWCA, PTA and Coalition of 100 Black Women.

Reginald L. Amory, Class of 1954.

After his high school years, Mr. Amory worked directly to the top of his field in civil and structural engineering. After receiving his bachelor's, master's and doctorate degrees, he became a professor, researcher, businessman, policymaker and scientist. He was president and founder of a high technology research and development company. Reginald Amory was dean of the Engineering School at A&T State University in North Carolina.

Jo Anne Futrell Lee, Class of 1959

With a registered nurse accreditation, Joanne has been able to fulfill her lifetime goals while also working with Lee's Funeral Home in White Plains as a licensed embalmer and funeral director. She is an educator, civic leader, businesswoman, traveler and family person.

Melvin T. Bolden, Class of 1963

Mr. Bolden served on board a U.S. Navy destroyer between 1963 and 1967. He then worked for thirty years with IBM until his retirement. Mel has worked with children at the Kiley Youth Center, St. Joseph's Home, Peekskill Parks and Recreation and the Nutrition Center. Melvin T. Bolden and John Curran collaborated on two publications, including Mrs. Jackson's *My Memories of 100 African American Peekskill Families*. He and his wife Stella, a registered nurse, have two sons. Melvin is a schoolteacher, producer and city councilman. Their son Anthony is a supervisor with AT&T in West Virginia.

Charles Fauntleroy Jr., Class of 1964

Mr. Fauntleroy retired as a manager at IBM. He was the financial secretary for the Peekskill Elks Lodge, and coordinator of Peekskill Housing Authority tenant activities. He volunteered as a member of Columbian Hose Company, Youth Bureau and the police civilian review board. He was once the manager for Choice of Colors choir.

Leon Lawrence, Class of 1965

After four years of service with the U.S. Air Force, Mr. Lawrence pursued a career with IBM. He later worked as a professional and volunteer with civil rights and diversity issues in Vermont.

James A Sullivan, Class of 1967

Mr. Sullivan's career in the U.S. Air Force led to outstanding management positions, such as with the White House Advance Team that coordinated President Reagan's visit to Normandy, France, in 1984. He was at one time the point person in coordination between Congress and the White House as superintendent of legislative affairs for the Pentagon.

Todd Scott, Class of 1983

Todd was an outstanding basketball athlete at PHS, scoring 2,057 points between 1980 and 1983. He was offered a basketball scholarship that led to his obtainment of a bachelor's degree from Davidson College. Todd worked for many years as vice-president of sales at IBM Corporation. He is a member of the Peekskill Education Foundation.

Jennifer Jordan, Class of 1988

Almost everyone who has watched television over the past ten years has seen Jennifer Jordon reporting on local cable news Channel 12, WOR-TV Channel 9 or as Westchester bureau chief for WCBS.

Edward Tre Johnson, Class of 1989

Tre's football experience at Temple University qualified him for the all-American League. Tre was accepted by the Cleveland Browns team in 2001. Tre Johnson's claim to fame was his time with the Washington Redskins when he was drafted by that team in 1994.

Holding both a bachelor's and master's degree, Mr. Johnson has sponsored free football camp trips for young people.

The Contemporary Scene

This is a work of history. While history is a study of events and people in times past, time is constantly free flowing. Some among us are making memorable history right now.

Authors

David E. Smith Jr., Glen Carrington, Offie Wortham and Carole McDonnell are contemporary Peekskill-based, African American, published authors.

David Smith and Bernard Adolphus authored *Finding Your Perfect Soulmate or Business Partner* by Destech publisher.

Leonard Carrington's son, Glen Carrington, has recently published a novel, *The Oakland Hills Vodou Murders*. The fictional murders are gruesome, with detective Lincoln on the case.

Carole McDonnell's book, *Wind Follower*, was published by Juno Press in 2007. The novel deals with several levels and interactions of humanity in her fictional world.

Offie C. Wortham is author of a 2004 illustrated, accessible biography of Peekskill's outstanding athlete in *The Elton Brand Story*.

Elton Brand

That Elton Brand is as Peekskill as anyone can be, that he is known by millions of people and that he has earned millions of dollars places him in a class by himself. Growing up in Dunbar Heights, attending Peekskill High School and leading the basketball team to a state championship was just the start for this national athlete.

Elton Brand is an excellent person in always recognizing his friends and coach here in Peekskill. He founded the Comprehensive Action Model for Peekskill as a small training center for young people about to enter the modern world. Court forward with the Los Angeles Clippers, Elton excelled at Duke University and then with the Chicago Bulls. He was recently selected for an all-star team and as a contender for Most Valuable Player.

Consistent in offering praise to PHS coach Lou Panzanaro, Elton Brand (born in 1979) always remembers his childhood buddies. Speaking of his award-winning high

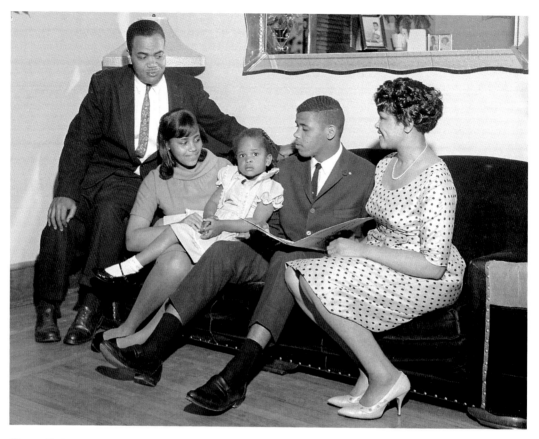

Kenny Duke sat with his family, Mr. and Mrs. Robert Duke and sisters Wyonella and Robin, after he received a Con Ed Athlete of the Week award in 1961.

school teammates, he was quoted in a *North County News* article in March 2007, written by Jim Mac Lean, as saying:

> *Once we broke through, these teams have been playing well, and I'm proud of these guys; you know, Mookie and them. I've known a lot of these kids since they were dribbling balls when they were five and six years old. I'm honored to be part of that history.*

Video producer Michael J. Minor produced an excellent videotape of Peekskill's basketball history. It features team members who took the state title games at Glens Falls in 1995 and 1996. *Peekskill High School Basketball* is a comprehensive 1997 video production with on-camera interviews of many local people. We can see and hear Kenny Duke, Bill Johnson, Charles Jones, Billy Thomas, Larry Ritter, Jeff Burns, Michael Ritter, Carlos Butler, Walter Corney, Monte Parks, Jimmy Robinson, Todd

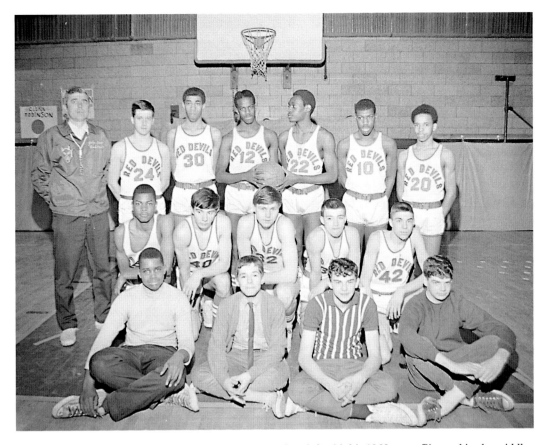

Peekskill High School basketball coach John Moro stands at left with his 1969 team. Pictured in the middle row, at left, is Robert Murphy. In the back row, starting at second from the left, are Glen Gaskins, Glen Robinson, Nate Carter, Len Robinson and Leon Burket.

Scott, Hugh Reynolds, Shawn James, Brent Dabbs, Tony Murphy, Tyrone Ritter, Larron Bailey, Tygee Washington, Derrick Robillard, young Elton Brand, Trevon Telford and Anthony Cuevas, along with Coaches John Moro and Lou Panzanaro. The narrator is WLNA's Gerry Desmond.

Elton Brand was co-producer of a major motion picture, *Rescue Dawn*, in 2007. Actors Christian Bale and Steve Zahn retell the true story of human endurance experienced by an American pilot during the Vietnam War.

Mr. Brand explained the film to the press:

> *It's a story of survival. It's more about friendship and inspiration, the trials and tribulations you go through in everyday life, and in a dire situation like a POW camp.*

Dr. Ernest Bates

While no longer active on the local scene, a notable Peekskill High School graduate (Class of 1954), Ernest Bates has been quite influential in national advancements in the science of medical care while based in California. Dr. Bates is a successful neurosurgeon in San Francisco. He is also chief executive officer of American Shared Hospital Services. Dr. Bates was involved in the development and implementation of the Magnetic Resonance Imaging scanner, or MRI, which allows complete methods of diagnosis for certain medical conditions.

Dr. Bates is a former member of California's board of governors for medical review, and is affiliated with many other prestigious organizations. He is one of nine agency members responsible for implementing a high-speed rail service in that state.

Diana Jones Ritter

Ms. Ritter is a Peekskill woman who was once chief assistant to the former State Comptroller H. Carl McCall. She is now administrator for the New York State Mental Health Department.

Valerie Swan

Ms. Swan has been a very effective director of Peekskill Youth Bureau since its formation in 1994. The bureau offers a variety of afterschool and summer programs for young people up to age twenty-one. The Invest in Kids program has involved nearly three hundred young people. A youth court forum allows corrective action without dealing with the legal system. A youth choir allows young people to create song in a harmonized setting. Several other programs focus on self-esteem, character building and making positive rather than negative or self-destructive choices.

A dynamic executive director, Ms. Swan has initiated support contacts with numerous local and county agencies, making the Peekskill Youth Bureau a model for other communities.

Melvin Burruss

Mr. Burruss is a lawyer, and is president of the African American Men of Westchester.

Started in 1987, AAMW sponsors many significant programs such as the Dr. King Legacy Youth Awards for public service, the Healthy People 2010 and business skills activities. Their website includes complete information.

PHS graduate Ernest Bates studied at John Hopkins University in 1957. Dr. Bates innovated medical procedures as a neurosurgeon in California.

Frederick Spry Sr.

Mr. Spry, as a state transportation supervisor, pushed for installing seatbelts on county buses. He was a longtime community volunteer with the Little League and the NAACP. A fitting stone and bronze memorial to Mr. Spry stands in front of the Field Library on Nelson Avenue.

Darrell Davis

Mr. Davis was a member of the Bohlmann Towers tenant patrol in the 1980s, and former chairman of the Peekskill Housing Authority. He and his committee for justice advocated forcefully against public surveillance cameras and for the restoration and modernization of Kiley Center. They have sponsored several community events including the African Heritage festivals at Riverfront Green Park.

Darrell has been a host of the radio program *Our World* on WLNA for many years, and he helped organize the Paul Robeson commemoration at Hollowbrook Golf Course.

Cordelia Greer

Ms. Greer is always pleasant to encounter in one's travels. After teaching English for many years at Lakeland High School and retiring from this career, she is active with Annsville Baptist Church and in various freelance commercial ventures.

She asks those whom she knows to call her "Candy," and when one hears her lovely soprano voice in the transcendent song of a spiritual or a European favorite, Ms. Greer remains enduringly memorable in one's mind.

Sandra Dolman

Ms. Dolman is certainly a familiar voice and presence at city council meetings. She is an outspoken advocate for low-income housing, and good government in all its functions. Showing her usual spunk, she ran for common council in 2001 and received sixty-nine write-in votes. She and Robert Zorn, who ran for mayor, produced a memorable eight-foot-long campaign pencil.

The public debate at that time was whether Peekskill was providing enough or too many opportunities for those who could not afford commercial apartment rental rates or house purchases. The political issue regarding homelessness has been focused on whether Peekskill is providing for its own people in need or is attracting other people from surrounding areas.

Sandra was personally involved in the Drum Hill Junior High School incident that resulted in expulsion for many students when they marched in protest to the high school in 1968. Ms Dolman explained, "We didn't respect the flag because it wasn't representing the interests of all people, as in 'Justice for All.'"

Peekskill's black basketball team members at the high school threatened to quit the team in sympathy with those expelled on the eve of an important championship game. The student protestors were allowed back into school. Sandra recalled that Drum Hill School then had about a 75 percent white to 25 percent black student ratio at that time, with very few Hispanics then present as students.

Affiliated with the local Black Unity party and later a member the Black Panther Party until the early 1970s, Ms. Dolman and about twenty of her friends at the high school (then on Ringgold Street) refused to stand during the "Pledge of Allegiance" and national anthem. Sandra went on to graduate from PHS in 1972. She has since worked as a seamstress with "Disabled People on the Move," and with the board of the county mental health agency.

Kazi Oliver

Kazi Oliver's African-style drummers generate energetic rhythms that reflect the intense dynamics of musical feelings. From Trenton, New Jersey, Mr. Oliver performs and educates with numerous school and civic groups in the Hudson Valley.

Dunbar John

Mr. John was a write-in candidate for mayor in 2005. A registered nurse and family man, he owns property on John Street. A twenty-year resident, Mr. John brims with ideas about how to improve Peekskill. Critical of both Republicans and Democrats, Mr. John advocates for quality standards of living for everyone through an affordable housing program, for universal healthcare with a nationalized healthcare system and for an education system that follows through on its interest in encouraging children to be productive adults.

He would like to see math, reading and science classes at the Kiley Center, stating, "We need to make champions out of second chances. When each child succeeds, America succeeds." The native of Grenada would also like to see the position of Peekskill mayor become full-time.

Roger Hamilton

Roger Hamilton is a familiar presence in the downtown area as a businessman, community promoter and friendly individual. Roger relocated from Harlem to Peekskill, where he has since been involved in many community activities and organizations.

As the owner of Brush Graphics, Mr. Hamilton has held wonderfully successful annual Christmas parties at the Paramount Center since 1997. Each child who shows up leaves with a gift and a smile on her face. With months of planning and behind-the-scenes work by so many people, this community Christmas event is always a big hit while appearing effortless.

When one speaks of a "second chance," Roger Hamilton's experience in receiving lifesaving liver and kidney transplants has allowed him to continue his work, good deeds and family activities.

Brush Consultants and Global Entertainment also sponsored an original musical production in 2006 at the Paramount, *He Will Not Change*, which told history of gospel music and was produced and written by John and Lila Wilson. And don't forget that Roger Hamilton has sponsored the Old Time Stickball game events, dishing trips and personal-realization conferences.

John Payne

Mr. Payne is fairly new to the downtown business scene. The scope of his professional and artistic experiences have been enhanced by his close association with the 1960s civil rights leaders. As the staff photographer for CORE in New York City, Mr. Payne had special access to visually record the leading people of those decisive years in American history.

John has recently established the VanGlen Art Gallery on Main Street, using a name coined from his children's names. The gallery showcases contemporary artists who work in various media and styles.

Marvin T. Brewer

Mr. Brewer has worked as a community service officer for twelve years. He has also been a security officer at Bohlmann Towers for eighteen years with the Peekskill Housing Authority.

Anyone who spends any time in the downtown area is familiar with Marvin as a longtime parking meter checker and traffic control officer. One could not receive a parking ticket from a more fair, firm and genial person. Mr. Brewer moved to Peekskill from the Bronx in 1984.

Thomas Dabbs

Anyone familiar with the Peekskill music scene knows Thomas Dabbs for his appealing musical talent. His soothing tenor voice, wide vocal range and extensive song knowledge provides pleasure to many thousands of people at numerous events.

Tom Dabbs's solo performances, his harmonizing in the Choice of Colors ensemble, or his heartfelt spirituals with the Mount Olivet Church choir are memorable because the musical quality is so far above the average.

His vocal range and knowledge of American songs are astonishing to those who listen carefully. Tom can sing the appealing "Amazing Grace," "O Holy Night" and "Stand" with equal clarity and power. When asked, Tom mentioned that "My Girl" by the Temptations is one of his favorite tunes to sing.

A 1963 PHS graduate, Tommy Dabbs has remained true to his hometown. He was always available for performance events requested by classmate and New York Governor George Pataki for twelve years.

Choice of Colors performed at the Paramount Center when the Temptations were in town. They also performed at an after party following the Neville Brothers in 2007. Tom's pleasant personality and accomplished musical talents clearly make him a notable and valuable part of Peekskill's community story.

Acknowledgements

The following people contributed material of substance to this book project: James Taylor, Offie Wortham, Allison Tapley Thompson, Kathleen Amory Moshier, Renee Smith, Donald Duren, Sandra Dolman, Leonard Carrington, William Johnson, Geraldine Kearse, Mrs. Jessie Bolden, La Fern Joseph, Waymond Brothers, Adrienne Wheeler, Audrey Overby, James Overby, Mrs. Ida Wiggins, Pauline Hinton, Carrie Harnetha, Lewis Purvis, Robert Boyle, Kathy Daley, Robert Mayer, Frank Goderre, Edward Choma, Jill Fisher and Norman Haight Jr.

Special thanks to Mr. Jack Murphy, former editor of the *Evening Star*, for rescuing the photographic archives of that daily newspaper for reproduction in this publication.

Mr. Lorman Augustowski of Merit Printing and Publishing scanned all the photographs and graphics for this publication.

Author's Works

John J. Curran is a Peekskill High School graduate from the Class of 1963. He has been Peekskill's official historian since 1994.

He is the author of the following published works:
Peekskill: A Photographic History (Arcadia, 2005)
Attack at Peekskill by the British in 1777 (Higginson Books)
Old Peekskill's Destruction in the 1960s & 1970s (Peekskill Museum)
The American Civil War: A New and Concise Version (Historical Briefs)
Influence of Hungarian Immigrants in Peekskill (City of Peekskill)
Chronological History, Peekskill, New York (City of Peekskill)
Our Next Step: Interplanetary Reunion (BC Publishing)
From the River's Edge to the World Beyond (Novel)

He composed the narrative and sequence for these historical videos:
Peekskill in Perspective
Peekskill on Postcards

He also edited and published *My Memories of 100 African American Peekskill Families*, authored by Ethel Jackson (1997).

Visit us at
www.historypress.net